IMAGES
*of Modern America*

# ALONG THE
# MORRIS CANAL

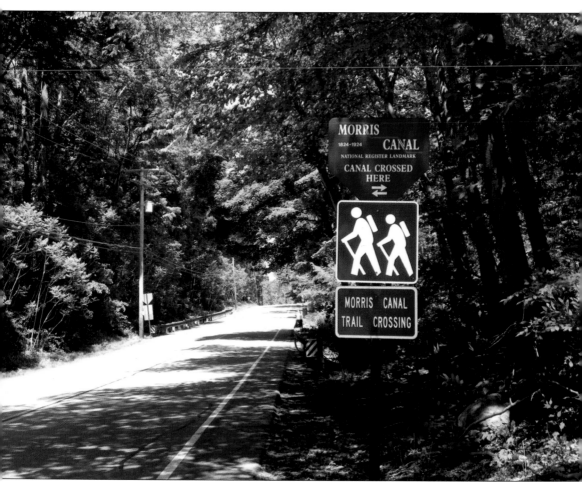

Along the roads between Jersey City and Phillipsburg, brown National Register Landmark signs proudly show the pathway of the historic Morris Canal. Large portions of the pathway were filled in or covered by economic growth; however, sections of the canal prisms, outbuildings, and towpaths have survived in the more rural areas of New Jersey. (Author's collection.)

On the Front Cover: Clockwise from top left:
Newark mural boatman (author's collection; see page 74), mule bridge stone abutment (author's collection; see page 28), restored Lock 2 East, Wharton (author's collection), Jersey City Little Basin Park (author's collection; see page 72), Morris Canal Trail, Starport (author's collection; see page 47).

On the Back Cover: From left to right:
Waterloo Mule Bridge (author's collection), Newark mural boatman (author's collection), National Register Landmark Morris Canal sign (author's collection).

IMAGES
*of Modern America*

# ALONG THE
# MORRIS CANAL

Amy Stewart-Wilmarth

ARCADIA
PUBLISHING

Published by Arcadia Publishing
Charleston, South Carolina

Printed in the United States of America

Library of Congress Control Number: 2013950659

For all general information, please contact Arcadia Publishing:
Telephone 843-853-2070
Fax 843-853-0044
E-mail sales@arcadiapublishing.com
For customer service and orders:
Toll-Free 1-888-313-2665

Visit us on the Internet at www.arcadiapublishing.com

*Dedicated to my sons, parents, close friends, and family for their encouragement and support, and to my husband, Rick, my devoted exploring companion.*

# CONTENTS

# ACKNOWLEDGMENTS

I enjoyed working with the following individuals, and I greatly appreciate their time and their particular expertise: Miriam Morris, president of the Roxbury Historic Trust Inc.; Susan Rawlinson, Roxbury Historic Trust Inc.; Derek S. Reilly; Bob Conley; Richard Rockwell, trustee of the Historical Society of Bloomfield and founding member of Friends of the Collins House; Joe Macasek, president of the Canal Society of New Jersey; John C. Manna, Wharton Borough grant coordinator and president of the Canal Day Association; Andrea Proctor, resource interpretive specialist for Waterloo Village; Valerie Smith, senior reference/technology librarian, Roxbury Public Library; George Hawley, Kathy Kauhl, and Tom Ankner, reference librarians at the Newark Public Library; John Beekman and Danny Klein, reference librarians at the New Jersey Room, Jersey City Free Public Library; Martha Capwell Fox, the National Canal Museum; John Bickler; David John Rush, artist; Marge Cushings, Roxbury Township Historical Society; and Kathy Fisher, president of the Montville Township Historical Society.

I also wish to thank my editor at Arcadia Publishing, Katie McAlpin, for her guidance and encouragement.

And special thanks goes to my husband, Rick Wilmarth, for helping me explore the Morris Canal, and for his encouragement while writing this book.

Unless otherwise noted, all images are from the author's collection.

# INTRODUCTION

Walking along the towpaths and empty prisms of the Morris Canal, I imagine life during canal times. I am in awe of the brains and brawn behind the building of this unwavering waterway, and of the endurance of the boatmen and their families as they worked and lived on the canal.

This is a collection of photographs of the Morris Canal in modern times. Included are chapters dedicated to the preservation and restoration efforts from the 1960s to the present day. A chapter of photographs taken from 2007 to 2013 tracks the canal from Jersey City to Phillipsburg as my husband and I searched and explored its historic remains. The changing seasons evoked visions of seasons past. Through the remnants of the canal in different stages of decay, we appreciated the craftsmanship and lost beauty, and we gained an understanding of the hardships experienced by the canal community.

A chapter of canal definitions is included as a visual portrayal of its key parts. We found more physical remains of the canal in rural areas, using only public access as we searched; we did not knowingly go onto private property.

The early 19th century was a time of growth in the United States, but the roads were difficult to traverse. Transporting cargo by land was expensive and took a long time. The profitable iron-ore industry had started to fail in Northern New Jersey because of this poor system of transportation.

The Morris Canal, often referred to as an "engineering marvel," came to life as the idea of George P. Macculloch, a businessman from Morristown, who saw the need to bring anthracite coal less expensively through Northern New Jersey. The Morris Canal and Banking Company was formed in 1824 as a private corporation. It was chartered by the state to build an artificial waterway from the Passaic River to the Delaware River.

Constructing the canal included building aqueducts, bridges, tunnels, locks, and inclined planes. A dam was constructed at Lake Hopatcong to raise the water level of the canal system. In 1831, the first trip on the canal, from Newark to Phillipsburg, was made. Later, a span of canal through Jersey City was added to bring access to New York Harbor, making the canal 102 miles long. It took five days for a canal boat to travel the length of the waterway while being pulled by two mules along the adjacent towpath.

Using 23 inclined planes and 34 locks (23 lift locks and 11 guard locks), the Morris Canal conquered the mountains of Northern New Jersey. It climbed out from the Delaware River to the canal's western terminus in Phillipsburg, upward to its highest elevation (at Lake Hopatcong), and down into the Hudson River at Jersey City, the eastern terminus. The inclined planes were unique to the Morris Canal.

Canal traffic started to wane due to the introduction of the railroad and to falling demand for iron from the area. The railroads were able to carry goods faster and cheaper. What the canal boat did in a five-day trip (and not at all in the wintertime), the railroads did in just hours, year-round. The Central Railroad of New Jersey and the Lehigh Valley Railroad eventually replaced

the Morris Canal. The canal was closed and abandoned from 1924 to 1929. Since then, a great deal of the canal had disappeared, and the surrounding landscapes became overgrown with vegetation and commercial development.

The Central Railroad of New Jersey terminal and ferry closed in 1967, and the Lehigh Valley Railroad went bankrupt in 1968. However, the 1960s was a time of revival for the Morris Canal. Early advocates included Percival H.E. Leach and the Waterloo Foundations for the Arts in Waterloo Village and The Canal Society of New Jersey, started in 1969. Significant achievements by individuals and organizations in preservation and restoration have continued to the present day.

The efforts of safeguarding the canal have seen both triumphs and disappointments over the years. Public and private funding (when forthcoming), volunteer efforts, and advocacy against modern encroachments continue to play crucial roles in its survival. The Morris Canal was listed in the New Jersey Register of Historic Places in November 1973 and in the National Register of Historic Places in October 1974.

The Morris Canal Greenway is an ongoing endeavor of the Canal Society of New Jersey, and it is being carried out under the guidance of the society's Morris Canal Greenway Committee. With a purpose to preserve, interpret, and offer recreational opportunities along the canal, its ultimate goal is to connect a statewide pathway along the entire route of the Morris Canal, linking the greenways in each of the six counties the canal passed through: Hudson, Essex, Passaic, Morris, Sussex, and Warren.

There are a great number of preservation alliances involved with the canal's conservation. Included in these groups and through private initiative, dedicated volunteers' devotion and generosity are apparent every time someone enjoys a preserved section of the Morris Canal.

The Morris Canal Greenway can be seen in each of the counties the canal passed through. Along its route, information kiosks provide canal facts specific to that section. Guided walks by the Canal Society of New Jersey and the Morris Canal Greenway are also available, and visitors can explore on their own with the help of the brown National Register Landmark signs posted along the roads of Northern New Jersey, showing the canal's route.

Space does not permit the inclusion of all the towns that have a preserved area; however, one can find lists of the Morris Canal preserves, parks, and trails online at the Morris Canal Greenway and Canal Society of New Jersey websites. Local historical societies are often a valuable resource as well.

A tremendous amount of dedication and care has gone into commemorating and preserving the history of the Morris Canal. Continued work and commitment is needed for future generations to be able to experience and appreciate this "engineering marvel" and its impact on the communities and history of New Jersey.

# One

# FEEDING THE MORRIS CANAL

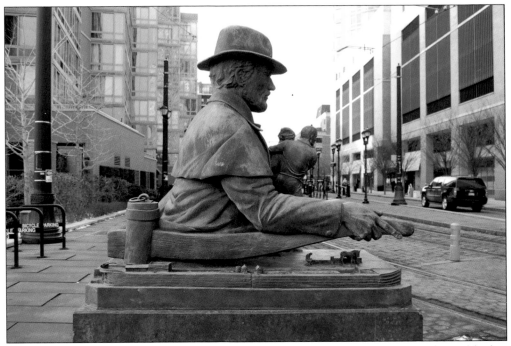

This is a statue of George P. Macculloch, whose vision led to the Morris Canal. He felt that the canal would be a shortcut for transporting Pennsylvania coal to New Jersey and New York markets. The statue is in Paulus Hook, Jersey City, near the canal's eastern terminus. (Photograph by Derek S. Reilly.)

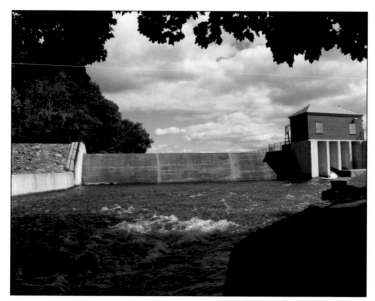

This dam at Lake Hopatcong was built to replace the first dam when the Morris Canal closed. Lake Hopatcong, the major water supply for the Morris Canal, was created from two smaller lakes for this purpose. Among the canal's other water sources are the Rockaway, Passaic, and Hackensack Rivers, Saxton Falls, Waterloo Lake, Cranberry Lake, Lake Musconetcong, and the Lopatcong Creek.

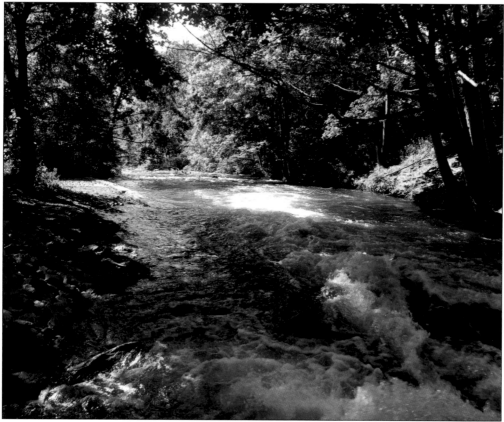

The Musconetcong River, pictured here leaving Lake Hopatcong, was part of Macculloch's initial idea of "damming Lake Hopatcong in order to deepen it and then connect it via canals along the Musconetcong River to the west, and the Rockaway River Valley and the Passaic River to the east," as stated in Wharton's Lock 2 East Report in 2008.

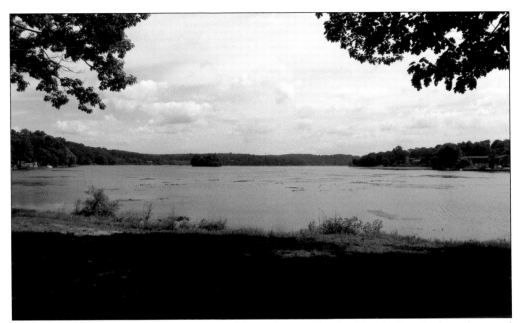

Lake Musconetcong was built to deliver additional water for the Morris Canal when the canal was being enlarged. A dam was built to create a canal reservoir when it was realized that Lake Hopatcong would not be able to provide enough water for the western part. The canal and a raised towpath crossed Lake Musconetcong.

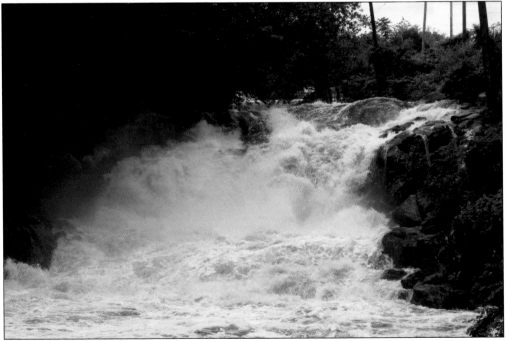

Pictured here is the Rockaway River flowing over the Boonton Falls. The Morris Canal ran alongside the river in many towns, including Boonton, Wharton, Denville, and Dover. The first village of Boonton was covered by the Jersey City Reservoir and is located east of today's Boonton, which was created by the building of the Morris Canal and the New Jersey Iron Company.

The Morris Canal, an important source of waterpower, had numerous streams, lakes, and rivers. The Pompton Feeder (above), entering along the canal's 102-mile stretch, helped to maintain its water level. This feeder canal, seen here with its towpath on the right, brought water from Greenwood Lake and the Ramapo River to the eastern section of the canal. The main canal and this six-mile-long feeder canal met in Mountain View. Below, the Pompton River is seen from a parking lot that was once the canal basin in Mountain View. The Pompton Aqueduct carried the canal over the river.

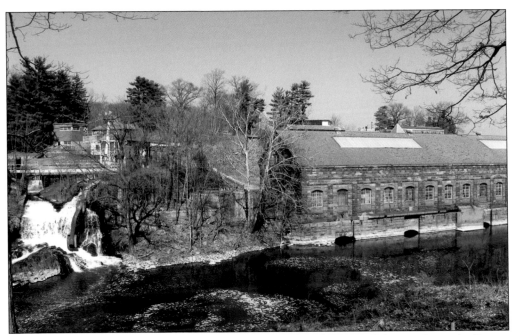

Brownstone in Little Falls was used in building the aqueduct that carried the canal over the Passaic River and to construct the canal's retaining walls. This photograph of the Beattie Mill on the Passaic River was taken from the Little Falls Morris Canal Preserve. The aqueduct, dynamited in 1925, was located to the far left of the mill.

Waterloo Lake, with the Musconetcong River flowing through it, was another source for the Morris Canal at Waterloo Village. The lake was used for ice cutting during early times, and icehouses were located along its shore. Before the trains came through, local residents cut ice for their own use.

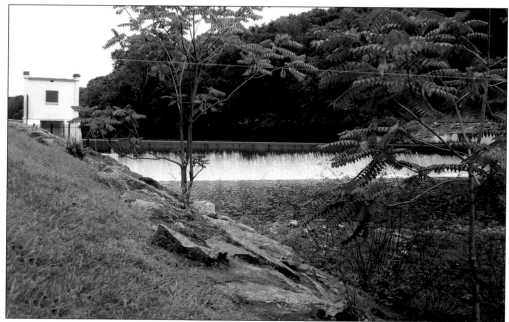

The Musconetcong River was dammed at Saxton Falls to create Saxton Lake and to function as part of the Morris Canal. The lake was a reservoir that stored and fed the Musconetcong River into the canal. The canal joined the Musconetcong River, and Lock 5 West allowed the canal to leave the river and flow in a southwest direction. Saxton Falls is part of Allamuchy Mountain–Stephens State Park.

Before the Morris Canal, coal from the Pennsylvania area was transported to eastern cities down the Delaware River and up the New Jersey coast. Interest in the Morris Canal was spurred by this inconvenience and the success of the Erie Canal. This is a view from atop the western terminus arch, across from where the Lehigh and Delaware Rivers meet.

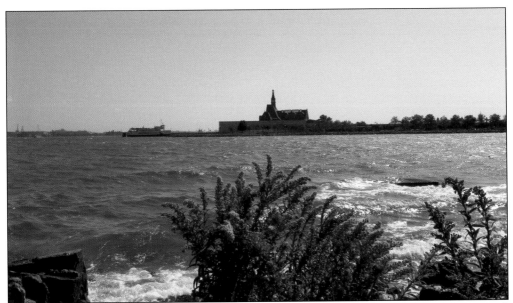

The Little Basin was the original Morris Canal basin in Jersey City, but it became too small to handle the growth in canal traffic. The Big Basin, seen in this photograph along with Ellis Island in the distance, was built to the south of the Little Basin in 1859 to accommodate this increase in traffic.

This stone viaduct supported the Ogden Mine Railroad. It was built to carry iron ore from Jefferson Township to Nolan's Point on Lake Hopatcong. From there, the ore was moved onto canal boats and then towed by a steam tug across the lake and out the feeder to the main canal. This process ended when the Central Railroad of New Jersey took over the Ogden Mine Railroad.

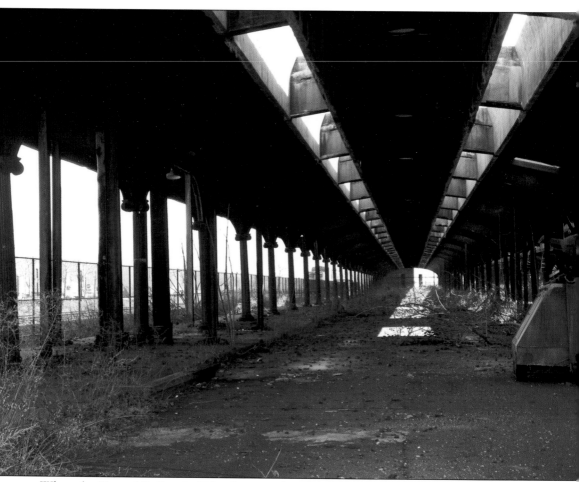

When the Central Railroad of New Jersey replaced the canal, it bought the area in Jersey City near the canal's basin, filling in the canal to build a new terminal. This is the historic train shed at Liberty State Park, near the Morris Canal Basin. Advocates for restoring it envision canal-related exhibits.

*Two*

# INTERPRETING THE MORRIS CANAL

The remarkable Morris Canal is entered through its western terminus arch on the Delaware River. At the top of this stone arch, boards were dropped into a slot (the vertical black line visible on the right arch) to prevent flooding and silt depositing on the inclined plane. In this chapter, the workings of the canal's key parts are defined through its traces and ruins.

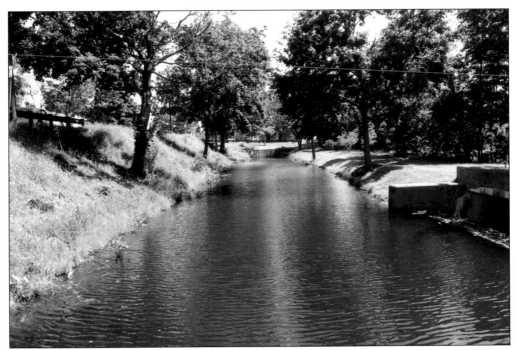

A canal prism is defined as the cross-section form of the canal bed and its embankments; a canal bed is the bottom of the canal. Before the Morris Canal was enlarged, the prism held 4 feet of water and was 32 feet wide at the top and 20 feet wide at the bottom. Its dimensions were later increased to 5 feet deep, 40 feet wide at the top, and 25 feet wide at the bottom to fit the new, larger canal boats. The photograph above shows a water-filled prism in Stanhope; below is a dry prism in Bread Lock Park. Both types of prisms can stir feelings for and appreciation of the past.

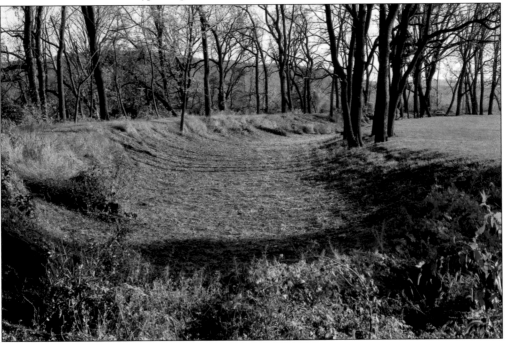

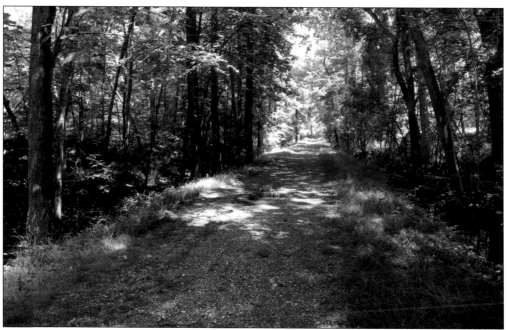

A towpath was a pathway alongside the canal, typically built along the sturdier canal bank. This path allowed the mules to walk beside the canal, pulling the canal boat. Some towpaths crossed over the canal on bridges. One type of bridge was a change bridge, which allowed the mules to cross over the canal without tangling the towrope. A change bridge was used when the towpath changed from one side of the canal to the other. Pictured above is the towpath along the feeder canal in Wayne; below, the towpath crosses the Musconetcong River in Stanhope on a replacement concrete bridge. The trees along the towpaths today would not have existed in canal times. The towpath had to be clear for boat traffic.

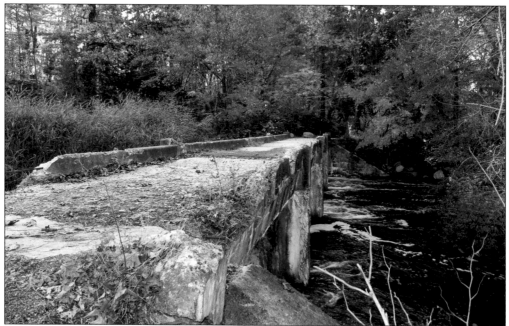

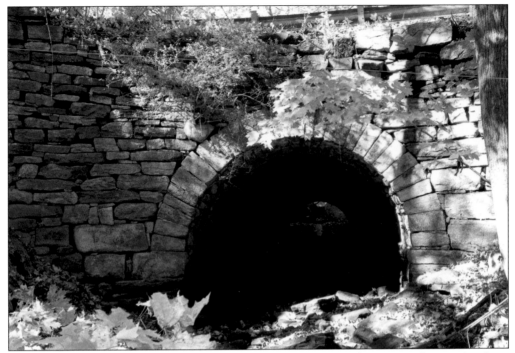

These photographs show both ends of the Morris Canal's stone culvert in Rockaway. A culvert allowed water to flow under a road, railroad, or other obstacle. Culverts were also installed within lock walls, used in the filling and emptying process. The canal used aqueducts when a larger obstacle was in its path. Rockaway's stone culvert, built in 1826, transported the Morris Canal over Fox's Brook. A road now covers the canal, but the culvert is still in good shape. In September 2013, a Morris County Historical Marker was dedicated at the culvert site.

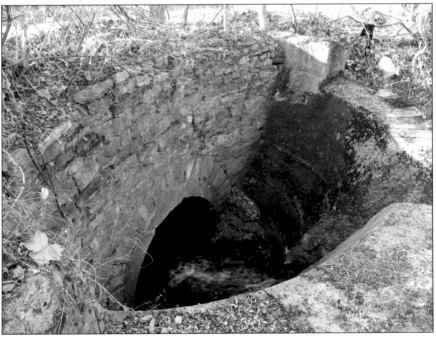

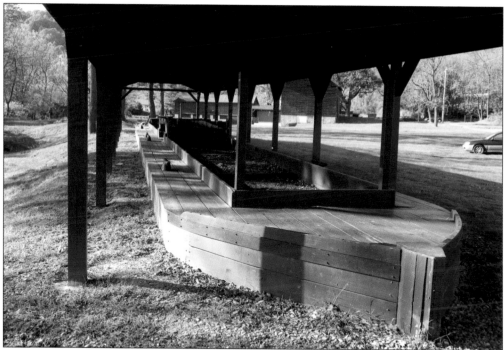

Flat-bottomed canal boats were built by the canal company. The first ones were able to carry 10 tons of cargo. Later, the boats had two sections and could carry up to 70 tons. In most cases, the boatman and his family or the crew lived on the boat during canal season, and mules or horses pulled the boats. The boats floated into the locks and over the inclined planes. Canal boats had limited storage and no refrigeration, so boatmen bought supplies from small stores at locks and inclined planes. These photographs show a canal boat replica at Bread Lock Park. The front of the boat is seen above, and the back of the boat is below.

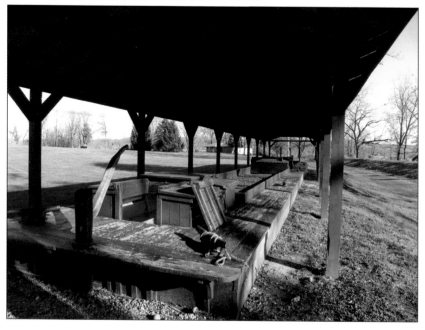

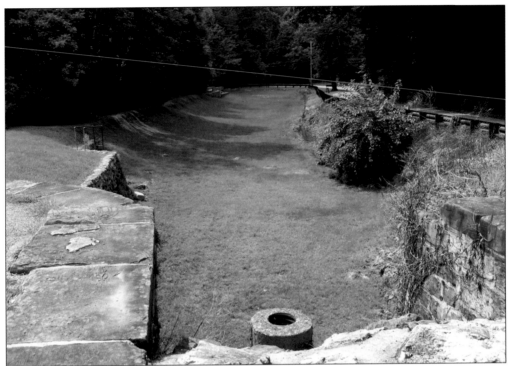

The Morris Canal used locks to climb elevation changes of less than 12 feet. There were 34 locks, including 23 traditional lift locks, as well as guard and tidal locks. The traditional lift locks were opened manually. All of the locks were built of stone with wooden gates except the tidal locks, which were made of wood to protect them from the saltwater. The original locks were 9 feet by 75 feet, later enlarged to 11 feet by 90 feet. The above photograph shows Lock 5 West at Saxton Falls. The newly restored Lock 2 East in Wharton is pictured below.

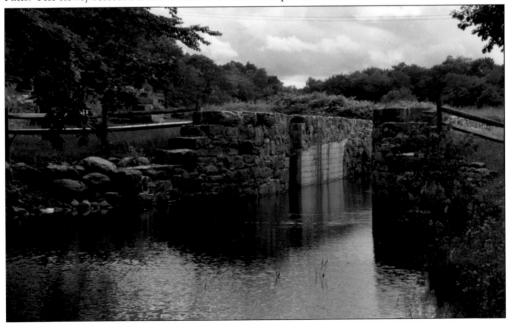

Canal boats waited in canal basins for their turn to move through a lock or to go up or down an inclined plane. Typically, basins were located along the canal and were also used as an area for boats to pass each other or turn around, for repairs, or for winter storage. Pictured above is the canal basin at Lock 2 East in Wharton, now a pond. Unfortunately, the canal prism along the other side of this basin is gone. The Port Murray canal basin is shown on the right. Still visible, it is located off the towpath in the Port Murray Dennis Bertland Heritage Area

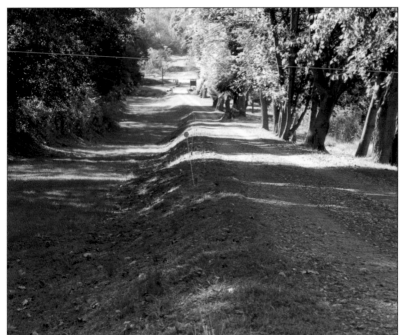

This is Inclined Plane 9 West, in Warren County. An inclined plane pulled the canal boats up or lowered them down its plane in cradle cars on iron rails using a heavy cable that was looped around a drum in the powerhouse, powered by water. The plane tender controlled the process.

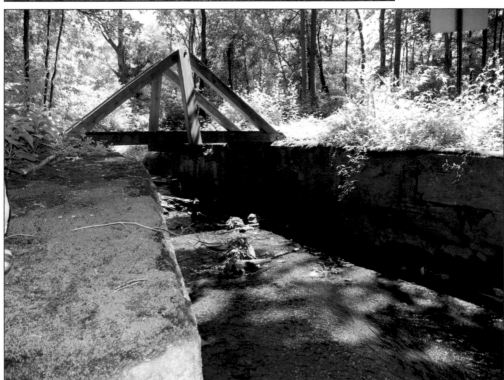

Pictured is a waste weir in Starport, used for overflow. It had a wooden gate and a towpath bridge over it. Excess water flowed over the gate, keeping the correct water level in the canal. The gate could also be opened to drain a section of canal for repairs. These stone walls are original, but they were cut down and topped with concrete during the canal's early dismantling.

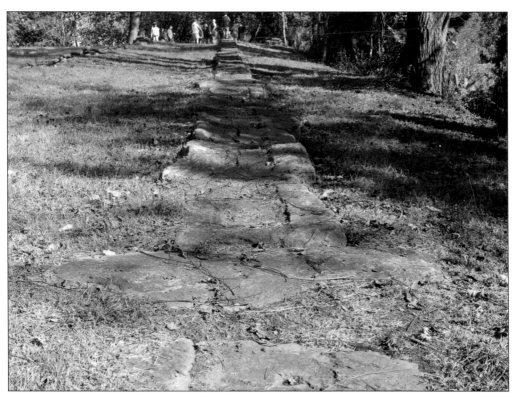

Pictured above are sleeper stones on Inclined Plane 9 West in Port Warren. Sleeper stones were massive stone blocks that supported the heavy wooden beams the iron rails were spiked to. Canal boats floated into a wooden cradle car and were pulled out of the water with a heavy cable along these iron rails, to the next section of canal. Spike holes and rail and cable marks can be found in remaining sleeper stones, as seen on the right at Plane 2 East in Ledgewood. There were two rows of stones to hold the one set of tracks. However, Plane 9 West was one of the three Morris Canal planes that had two sets of tracks, allowing boats to go up and down at the same time.

The above photograph looks into a ground-level opening of the turbine chamber at Plane 2 East in Ledgewood. A powerhouse contained the equipment and controls that ran an inclined plane. Large amounts of water from the upper level of the canal were directed down the powerhouse chamber to turn the reaction turbine. This provided the power to raise and lower the boats along the planes. Pictured on the left is the Scotch reaction turbine from Plane 3 East in Ledgewood, on display at Hopatcong State Park. It was moved there after the Morris Canal closed. The inclined planes, initially powered by waterwheels, were later replaced with the Scotch turbines.

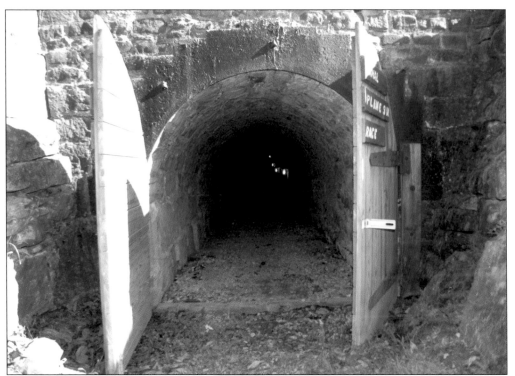

Pictured above is the tailrace tunnel at Plane 9 West in Port Warren. An inclined plane used water from the canal to power a turbine located in an underground chamber below the powerhouse. After the turbine used the water, it was removed from the chamber through a tailrace tunnel. From here it flowed into a bypass channel, rejoining the canal at the bottom of the plane. The bypass channel directed water around the inclined plane when the turbine was not running, maintaining the water level in the canal section below. The stone-lined channel shown below is a bypass channel at Plane 2 East in Ledgewood.

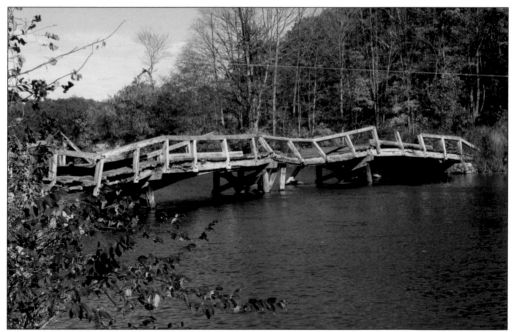

This bridge was built in the 1970s to replace the wooden bridge used to carry mules across the Musconetcong River as they pulled the canal boats. This bridge once connected the towpath from Waterloo Village in Sussex County to the other side of the river in Morris County. Since its collapse, the Morris County side and Inclined Plane 4 West have not been accessible to the public.

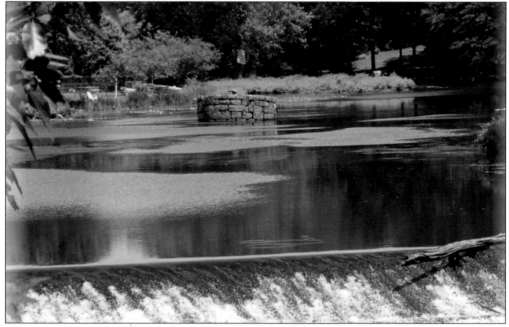

The stone abutment shown here supported the mule bridge that carried the towpath across the water. It crossed over this pond, created by the Rockaway River dam. This sight can be seen from the bridge where North Main Street and Powerville Road meet in Boonton Township. To the left of the stone support was Lock 10 East.

# *Three*

# EARLY RESTORATIONS IN MODERN TIMES

In the early 1960s, a modest version of a newly restored Waterloo Village by Percival H.E Leach and Lou Gualandi opened to the public. David John Rush, an artist, became friends with Percy Leach during this time. He designed the music tent, drew renderings of Leach's restoration ideas, and was there, helping, almost every day. Rush's artwork included watercolor paintings of Waterloo; one was of the historic gristmill.

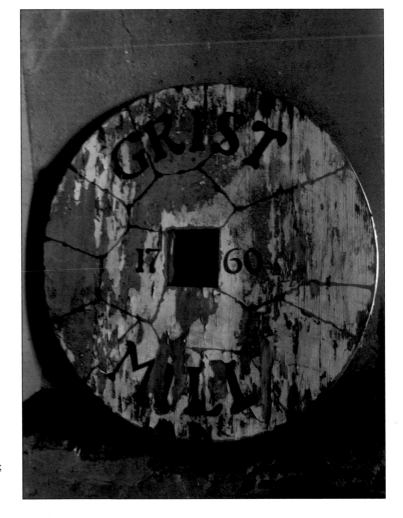

This is the Morris Canal Highway in 1954, under construction in the Morris Canal's right-of-way in Bloomfield. The highway is now called John F. Kennedy Drive. By the 1960s, a large part of the canal's remains were covered by John F. Kennedy Drive and the Garden State Parkway. (Courtesy of Art Bickler.)

This is John F. Kennedy Drive in the former Morris Canal's right-of-way in 1979. It looks the same today, except there are fewer trees. Bloomfield Township bought the canal's right-of-way when it was abandoned. There is one preserved section left, through Wright's Field, but there are no remaining watered sections. (Courtesy of Frederick Branch.)

Silas Riggs, a tanner, helped in the building of the canal. The Silas Riggs "Saltbox" House was saved from demolition by the Roxbury Township Historical Society in 1962. It was listed in the National Register of Historic Places in 1974 and in the Morris County Heritage Commissions Market Program in 1976. Pictured here is the program from the Silas Riggs House dedication in September 1976. (Courtesy of the Roxbury Public Library.)

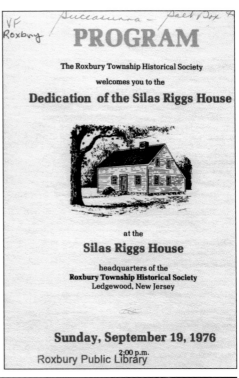

The Canal Society of New Jersey is a nonprofit organization begun in 1969 to promote awareness and education of New Jersey's two towpath canals and to preserve and restore canal remains and artifacts. Posing here are the founder, Clayton Smith (right), his wife, Mary Ann, and Percival Leach in June 1975, just before the opening of the society's museum. (Courtesy of the Canal Society of New Jersey.)

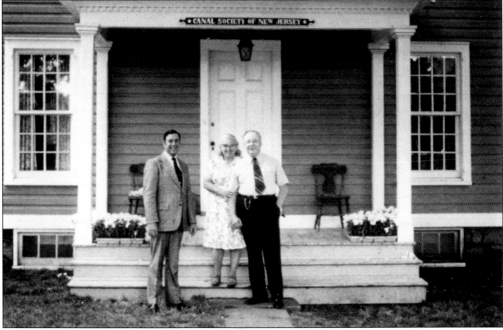

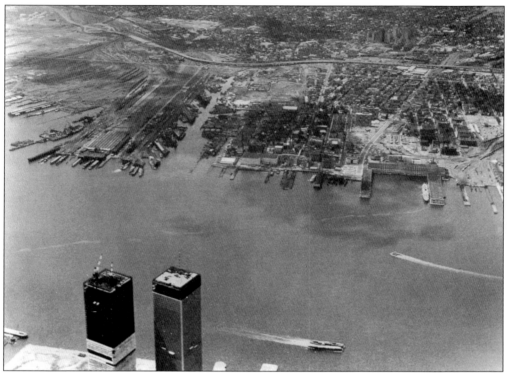

This early 1970s aerial photograph shows the Little and Big Basins. Directly across from the twin towers of the World Trade Center is the Big Basin, stretching inland. The Little Basin is to its right, with a peninsula between them. An undeveloped Jersey City and a future Liberty State Park are in the background. (Courtesy of the New Jersey Room, Jersey City Free Public Library.)

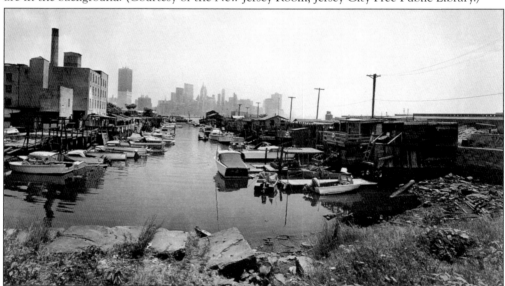

This is the Green Street Boat Club on July 1, 1970. Squatters built shacks and docks along both sides of the Little Basin after the Morris Canal was abandoned in 1924. They were ordered to vacate in 1984 so that the state could extend Liberty State Park. (Courtesy of Jersey City Free Public Library and Jersey Pictures Inc..)

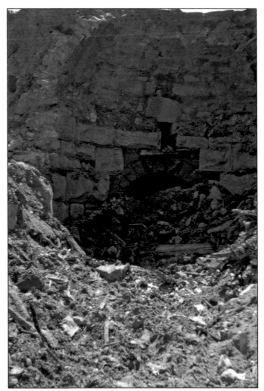

Pictured on the right are the remains of the turbine chamber at Plane 4 East in Wharton, sometime in the early 1970s. The site was also called Bakers Mill. This photograph shows soil removed from around the stonework and debris in the chamber. All traces of this plane have been removed. The below photograph, also taken in the early 1970s, shows the remains of the turbine chamber at Plane 5 West in Port Murray. The arch, covered here by vegetation, allowed the water used by the turbine to leave the turbine chamber and flow out to rejoin the canal. (Courtesy of the Canal Society of New Jersey; Barbara N. Kalata Collection.)

The remains of the turbine chamber's tailrace at Plane 10 West in Lopatcong, Warren County, are seen above. This photograph was taken in May 1973. The early 1970s photograph below shows the canal on the grounds of the New Jersey State Game Farm in Rockport. This section of canal was kept watered for the farm's use. The canal and intact towpath pass through the farm, now called the Rockport Pheasant Farm. The canal basin has been drained, but it is still visible. (Courtesy of the Canal Society of New Jersey; Barbara N. Kalata Collection).

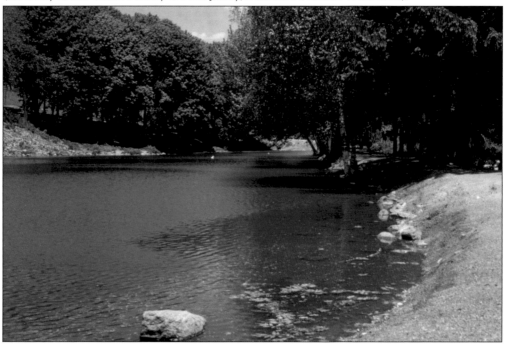

Albert Riggs, son of Silas Riggs, acquired the abandoned King Store in 1847. Built around 1826, it stood across from a Morris Canal basin and served as a canal and general store, post office, and gathering place. Albert Riggs's daughter, Emma Louise, married Theodore King, who took over the store in 1873. He made enough money to build the adjacent family home in 1878. The store is pictured here and below in 1976. (Courtesy of The Roxbury Historic Trust Inc.)

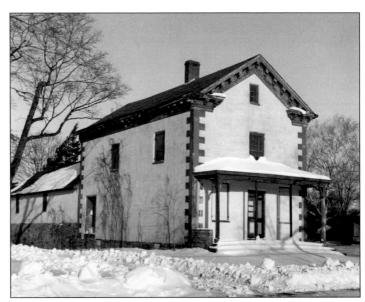

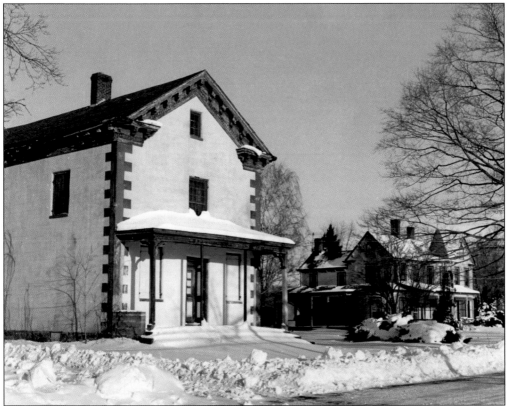

Roxbury Township purchased this site in 1984 with Green Acres funding. It was listed in the New Jersey and National Registers of Historic Places 10 years later. In 1989, the Roxbury Rotary Club began restoring the rundown King Store. The club began work on the King House (right) in 2000, when the Roxbury Historic Trust was incorporated to develop and maintain the buildings as museums. (Courtesy of The Roxbury Historic Trust Inc.)

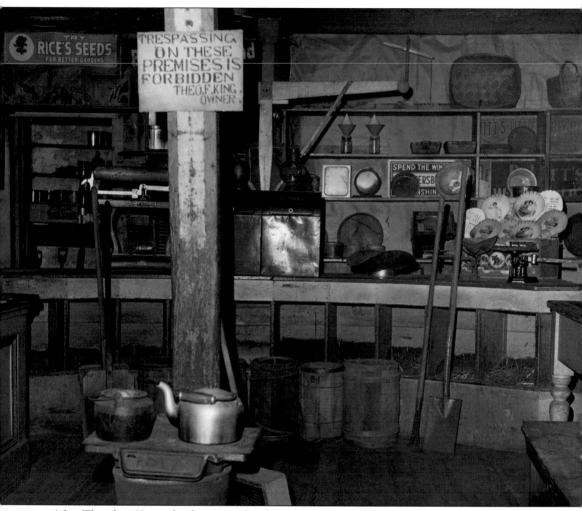

After Theodore King's death in 1928, his daughter Louise closed the store, and it remained locked and undisturbed until after her death in 1975. Her cousin Russell Wack took this photograph and others of the interior when the store reopened in 1976 for a fundraiser. The Roxbury Historic Trust Inc. is recreating the store, using these photographs as a guide. (Courtesy of The Roxbury Historic Trust Inc.)

# Four

# COMMUNITIES ALONG THE MORRIS CANAL

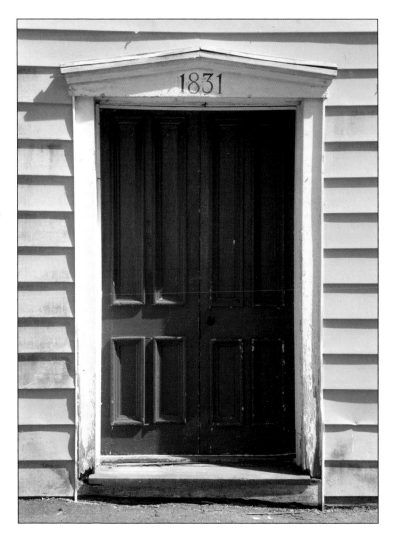

The Morris Canal unlocked opportunities and growth. New communities grew around the canal's locks and inclined planes, and existing towns and cities flourished. These communities provided supplies for the boatmen, shelter for the mules, and economic growth. Some towns have continued to succeed into modern times, and some declined after the canal's demise. This door belongs to the Port Murray canal store, now privately owned.

This is the Collins House in 1979. John Collins built it along the Third River in Bloomfield prior to the Morris Canal. His son Isaac and grandson John were both carpenters who worked on the canal and helped maintain many of its locks, bridges, and aqueducts. Inclined Plane 11 East, now John F. Kennedy Drive, ran across the Collins property. (Courtesy of Frederick Branch.)

Today's Boonton, once called Booneton Falls, developed along the rocky hillside overlooking the Morris Canal and the Rockaway River. This photograph is looking down Plane 7 East, now Plane Street. At the bottom of this hill was the lower basin; at the top was the upper basin. Both are now covered with asphalt, and upper Plane Street is a town parking lot.

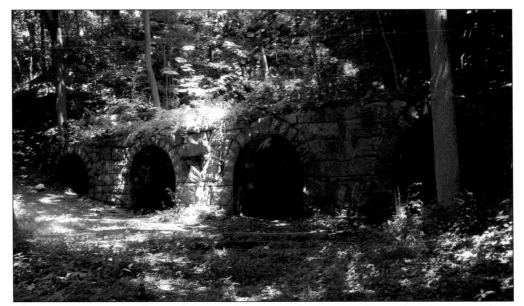

These are the remaining bases of the iron furnaces at the Boonton Ironworks in Boonton, above the Rockaway River and below where the canal flowed. Water from the canal's upper basin was redirected into the ironworks complex, providing power. The water then flowed back out into the canal at the foot of the plane. The Morris Canal Company leased the canal to mills and ironworks along its route.

E.C. Peer and Sons Store at Lock 8 East sold supplies and groceries to canal boatmen. Samuel Peer bought the property in 1852, and E.C. Peer was the lock tender from 1862 to 1915. The growth of the Village of Denville was slow until the construction of the Morris Canal. The store, now a restaurant, looks much the same, except a parking lot covers the lock, beyond the left edge of this image.

This is the oldest bridge still in daily use in Morris County. Located in Dover, this partially concealed stone arch bridge was built over the Rockaway River to relocate the old turnpike when the Morris Canal was constructed. Now covered by modern-day Sussex Street, the stone bridge is still in good shape.

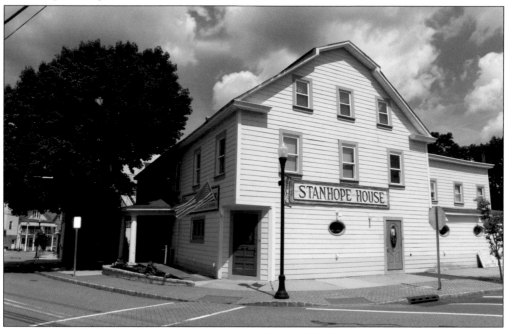

A small watered section of Morris Canal leads into the town of Stanhope. The Stanhope House (pictured) was a canal stop for boatmen and travelers. They could walk across Main Street from their boats tied in the canal basin and into the Stanhope House. It was also a stagecoach stop. The house continues today as a stop for entertainment.

Shown above are the remains of the Plaster Mill in Stanhope. The mill was built in 1800 along the Morris Canal's upper basin, using its water for grinding power. Businesses were needed to accommodate the canal boatmen, their families, and the growing communities along the canal, and the Plaster Mill was one of them. Stanhope became a main port of commerce on the Morris Canal, contributing to the growth of the ironworks industry. The photograph below shows the stone remains of the stop gate in the canal slip that once led from the canal basin to the Musconetcong Ironworks. Stanhope's iron manufacturing era ended soon after the demise of the Morris Canal, but Stanhope again experienced community growth with the building of interstate highways.

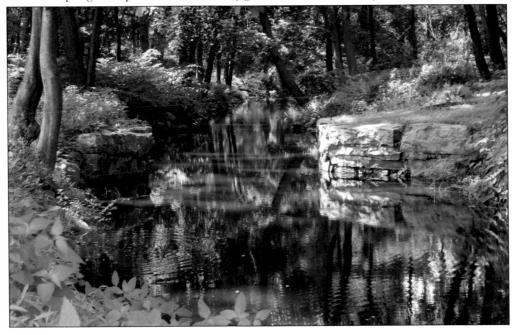

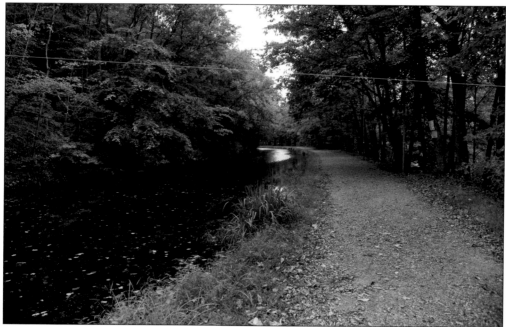

The Borough of Wharton restored this section of watered prism in 1976, now Hugh Force Park. A portion of the canal that is now the parking lot, from which this photograph was taken, was once used for swimming. The Morris Canal, local mines, and iron forges all contributed to the shaping of Wharton.

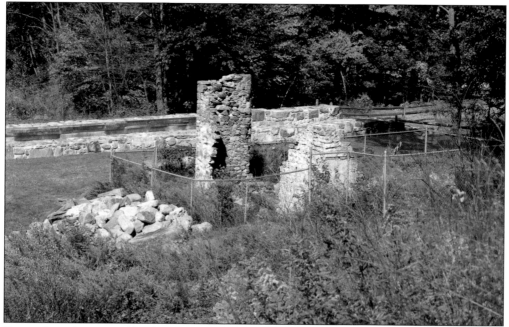

Pictured are the restored Lock 2 East and the remains of the lock house. During canal times, the landscape around Lock 2 East changed from an uninhabited area into a developing, populated place eager to help with the canal and local iron mines. Because of the canal, towns like Wharton became connected with distant markets, influencing these communities.

The Smith family built businesses and their home in Waterloo Village when they heard the Morris Canal was going to be built through the town. Generations of the Smith family were involved in the Smith General Store and Gristmill. The Peter D. Smith House (right), built in 1874, stood across the pond from the gristmill. Pictured below is the back of the store on a watered section of the canal. The store was built in 1831. Canal boats would pull up to the back of the store, where goods and supplies would be loaded or unloaded directly to or from the boats.

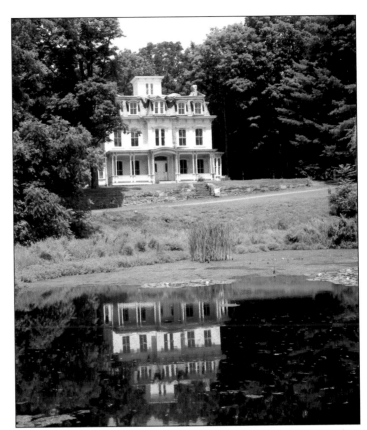

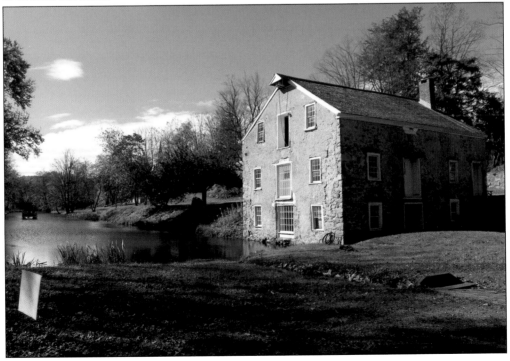

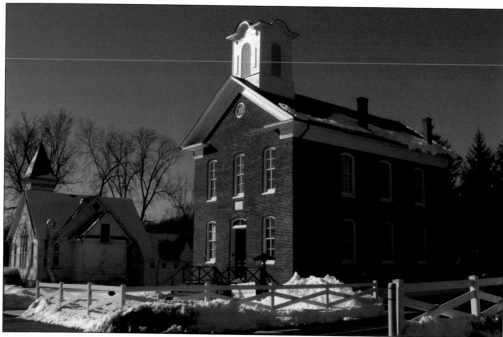

Port Colden, built when the Morris Canal was completed, was named after the president of the Morris Canal Company, Cadwallader D. Colden. The town developed around the canal's boat basin, but declined with the closing of the canal. Shown above is the Port Colden Schoolhouse, originally built on the banks of the Morris Canal basin in 1869. It is now located in the drained boat basin and was restored in 2003. The Port Colden Manor (below) was a stagecoach stop in 1850. It was abandoned as a hotel in the late 1800s. After the 1870s, Port Colden started to decline. It was listed in the New Jersey and National Registers of Historic Places in July 1998.

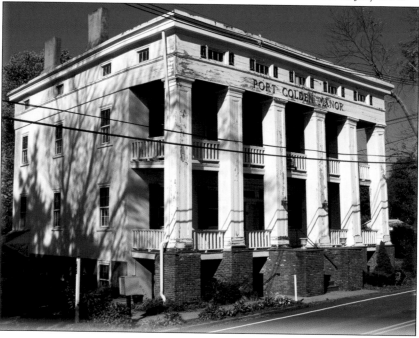

Lock 4 West's lock tender's house, seen here in 2007, is one of just a few such houses surviving today along the Morris Canal's route. After the canal closed, the building served as a local tavern called Elsie's for many years, until the early 1980s. (Courtesy of the Canal Society of New Jersey.)

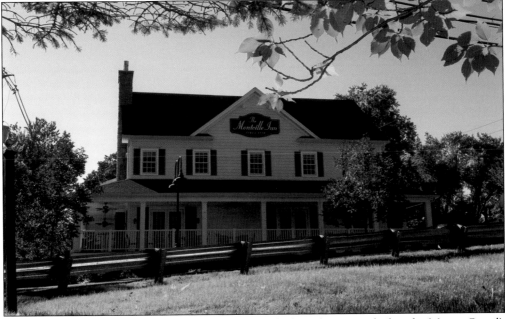

The Montville Inn, built in 1770, served customers before, during, and after the Morris Canal's existence. Another business, known today as the Columbia Inn, also survived into modern times. Built in 1870, it was later turned into an inn because of its convenient location near the canal. The canal closed in winter, leaving boatmen to look for temporary housing and work along the canal until spring.

The population in Rockaway grew when the canal passed through, becoming an inland port for iron ore and manufactured iron. The Rockaway Hotel (left) was built in the 1830s along the canal. It is still in the business of serving, but under a different name. This photograph looks down the canal's right-of-way, now covered by asphalt.

# Five

# TOWPATHS, PRISMS, AND TRAILS

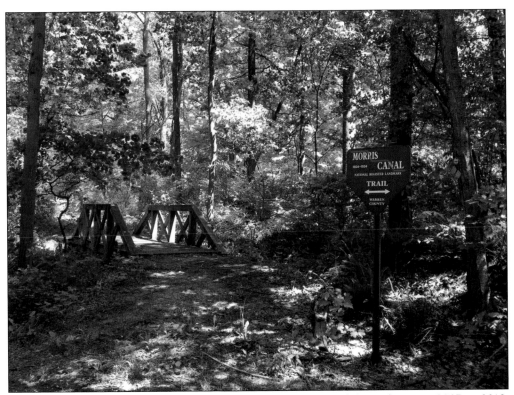

This chapter describes a modern-day flow of the Morris Canal from the years 2007 to 2013. Even after the discovery of a good portion of the canal's remains and a recovery of its history, there continues to be discoveries and new information. This trail in Starport is one of the many accessible trails along the canal.

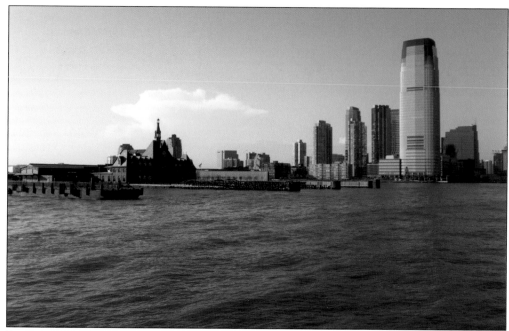

Boats entering the eastern terminus approached from the Hudson River, ready to journey along New Jersey's mountain-climbing canal. The Big Basin and Little Basin lie next to each other, with their entrances directly to the left of the tallest building. The basins are on the northeastern boundary of Liberty State Park.

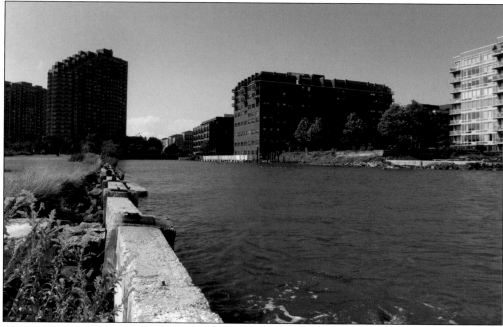

The Big Basin was built in 1859, as the Little Basin had become too small to handle the increasing Morris Canal traffic. The Little and Big Basins formed the eastern terminus of the canal in Jersey City. The Little Basin (shown here) is now part of Liberty State Park. The Liberty and Ellis Island ferries use the southern end of the Big Basin.

After the Morris Canal's abandonment, Newark created streets in the canal's right-of-way. The filled-in downtown section became Raymond Boulevard (pictured). Another part was used for a new subway. Newark was the original eastern terminus of the canal, prior to the 11-mile extension in 1836 to Jersey City.

The canal came into Bloomfield from Belleville, where it flowed along the Second River from Branch Brook Park. The canal can be seen on either side of Watchung Avenue in Bloomfield. The dry prism can be seen here through the brush. Though difficult to spot, a nearby Morris Canal Landmark sign helps point it out.

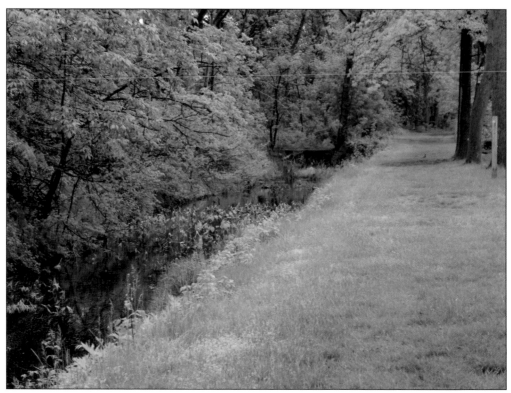

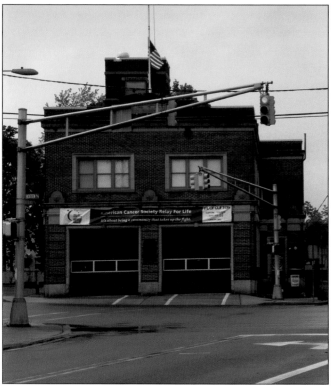

The canal traveled from Woodland Park and Little Falls into Clifton. Pictured above is the Morris Canal Park and Jack W. Kuepfer Sr. Nature Preserve, with a watered canal prism on the left and the towpath to its right. The preserved prism, 600 feet long, is located off Broad Street. The Clifton Historical Commission, Jack Kuepfer, and volunteers cleaned this out and created the park. It was once used as a dumping area along the Garden State Parkway. Following the route along Broad Street in Clifton, the canal flowed through what is now the intersection of Clifton and Van Houten Avenues, directly through the site of present-day Engine Company Six (left).

Flowing from Clifton into Wayne, the canal and the Pompton feeder canal joined in Mountain View, crossing the Pompton River on an aqueduct. This photograph shows a dry section in Lincoln Park, located up the canal from Mountain View. Lock 14 East was located in Lincoln Park; the longest section of canal without an elevation change was between this lock and Bloomfield.

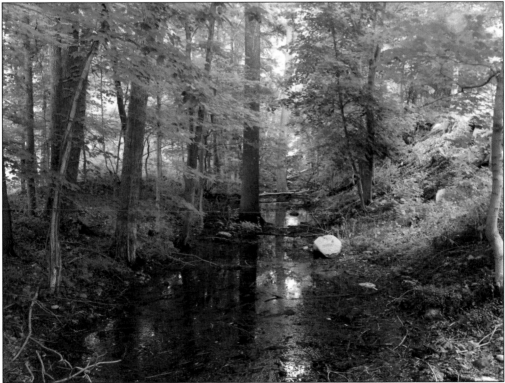

Heading in the direction of the western terminus, the Morris Canal came from Lincoln Park into Towaco. Shown here is an unpreserved section of canal prism with shallow water in Towaco. The prism sits between the road to the left and residential homes to the right. A change bridge was located not far up the canal in Montville.

This preserved 4,300-foot section of prism is in Montville, near the intersection of Changebridge Road and Main Street, where a change bridge was once located. Traveling through Montville, the Morris Canal needed three inclined planes to raise the canal boats the necessary 206 feet. This area, dedicated in 1988, provides recreation and storm-water management.

Plane 7 East, now Plane Street in Boonton, was 800 feet long with an elevation of 80 feet. From the top, once the upper basin, a visitor can follow where the canal used to flow, straight ahead through Canal Side Park and across West Main Street to Lock 12 East.

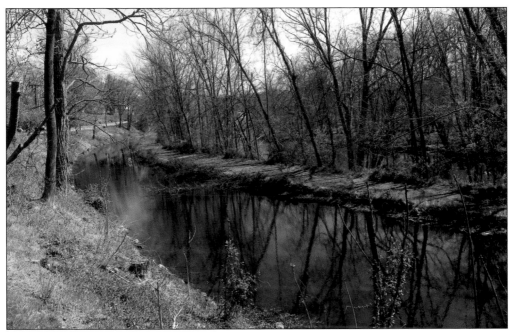

Emerging from Lock 12 East, this water-filled prism runs along North Main Street in Boonton. In this photograph, the towpath is to the right of the canal and stretches between the canal and the Rockaway River. This part of the Morris Canal is west of Lock 12 East and Inclined Plane 7 East in Boonton. It continues out toward Powerville Road and then to Denville.

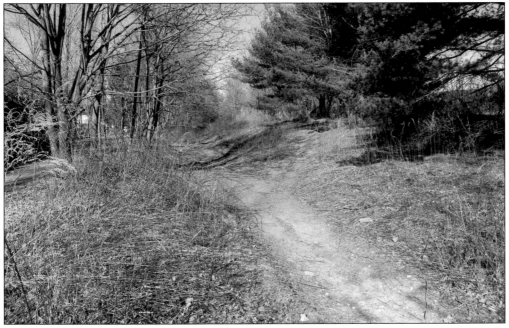

Heading through Denville Township, the canal ran along the Rockaway River. Here, the canal's empty prism is in the middle, with its towpath running parallel to Towpath Road on the left. At the end of this road are the remains of the aqueduct that carried the canal over the Rockaway River. The aqueduct and river were popular swimming and ice-skating areas back in canal times.

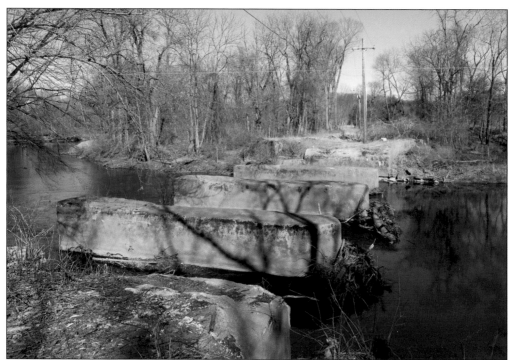

The above photograph shows one of the Morris Canal's eight documented aqueducts. The aqueduct, made of wood and supported on stone masonry abutments and piers, carried the canal boats across the Rockaway River in Denville Township filled with up to 70 tons of cargo. The E.C. Peer and Sons General Store and Lock 8 East were located near the aqueduct. The building is now a restaurant with a collection of historical canal photographs, tins, and antiques on display. The aqueduct remains are a part of the Morris Canal Historic District. Continuing toward the western terminus, the canal traveled into the Cedar Lake community toward Rockaway. Below, the canal prism is on the right and the towpath is on the left.

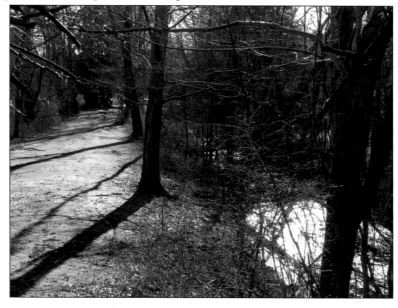

The above photograph shows Plane 6 East in Rockaway, now a church driveway. A parking lot is at the top of the old plane. Halsey Park is to the left, located where the upper canal basin was. Plane 6 East was built as a model inclined plane; this section of canal from Rockaway to Dover was one of the first to be completed. Traveling from Plane 6 East across what is now Wall Street in Rockaway, the canal passed over the stone culvert (below), through the town of Dover, and into Wharton.

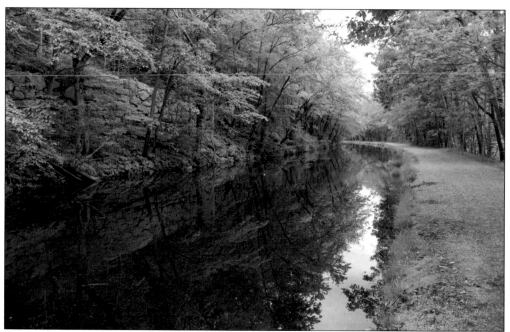

This is the Morris Canal in Wharton, one of the best-preserved water-filled sections of the canal. This half-mile section of canal runs above and to the left of the Rockaway River. At the end of the prism are Lock 2 East and the remains of the lock tender's house, which has been open to the elements since a fire in the 1970s.

The Morris Canal leaves the Wharton area, then moves through Kenvil and into Ledgewood. Shown here is a secluded water-filled canal prism discovered behind commercial buildings of the Morris Canal Plaza. The towpath was not accessible from the parking lot, but it is a pretty section to look at.

The canal continues to where Plane 3 East was located, then over to Plane 2 East. The planes raised the canal a total of 128 feet. This is Plane 2 East, located in the Ledgewood Canal Park. The plane is overgrown, but the sleeper stones can be seen climbing the inclined plane to the top, where a pavilion roof protects the open turbine pit.

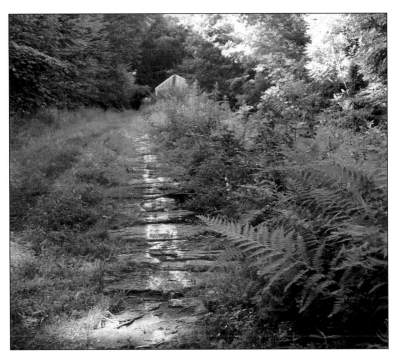

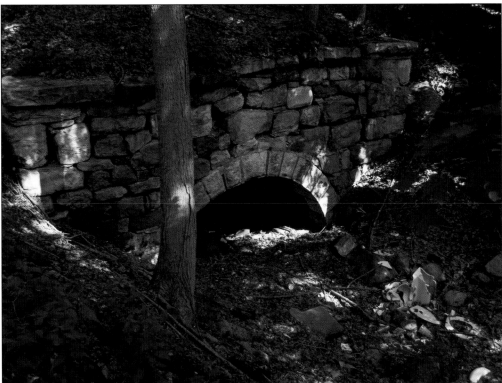

Leaving Ledgewood, the canal travels into Shippenport on its way to Lake Hopatcong, the canal's summit. Plane 1 East was located in Shippenport; it is now covered by a road. The remains of the plane's tailrace tunnel (pictured) can still be seen over one side of the road.

Above is the towpath alongside the dry prism of the feeder canal that connected Lake Hopatcong to the main canal. The feeder canal was also used to bring passengers to Lake Hopatcong's resorts. From here, the canal made its way to Port Morris. Below is a view looking down Plane 1 West into Lake Musconetcong. Port Morris got its name from being a port along the Morris Canal. The canal crossed the lake with the towpath positioned on a raised soil causeway, which can still be seen when the lake is periodically lowered. A small monument by the residential road marks where Plane 1 West once was.

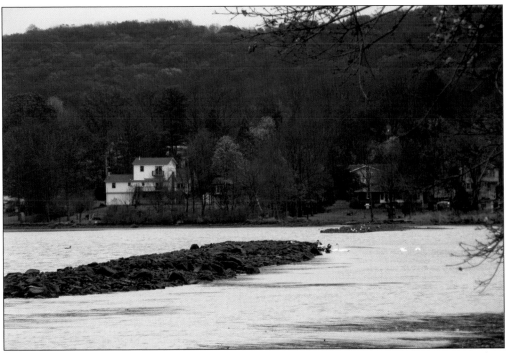

These photographs, taken from different vantage points, show the Morris Canal's raised earthen towpath across Lake Musconetcong. Most of this causeway was dismantled when the canal closed, but when Lake Musconetcong's water level is low, the remains of the raised towpath are visible. The towpath extended across the middle of the lake, from Plane 1 West in Port Morris, to Lock 1 West in Stanhope. The mules walked along the towpath, pulling canal boats along a channel in the lakebed. Above, the towpath is seen from the direction of Lock 1 West. More of the pathway is visible below, looking out from the Plane 1 West area.

This is Lock 1 West at Lakeside Park in Stanhope. The lock was filled in, but the capstones on the top of the lock walls are visible. The capstones outline the lock and direct the viewer down its length to Lake Musconetcong in the background, built as a canal reservoir.

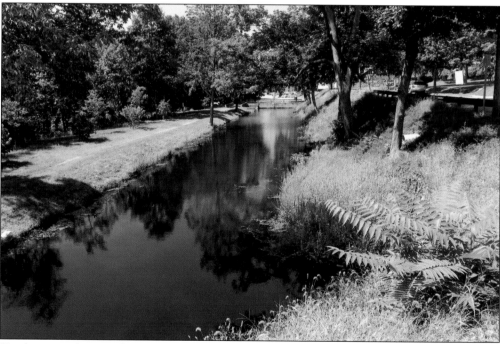

Heading west from Lock 1 West and across Route 183 is this small, preserved watered section of the Morris Canal that leads into the town of Stanhope. Here along the canal there were stores and businesses, including the Plaster Mill, built in 1800. The ruins of the Plaster Mill are still present. The Morris Canal, and the local ironworks it supported, were major contributors to Stanhope's growth.

Pictured at right is Plane Street in Stanhope, formerly Inclined Plane 2 West. As the boatmen followed the canal through town, they approached Plane 2 West, once running between present-day Plane Street and Plane View Street. At the top of the inclined plane was the upper basin; the lower basin was at the foot of the plane. A concrete bridge (below) was located at the foot of the plane and to the right of the remaining lower basin. This bridge is where the towpath crossed the Musconetcong River, replacing a wooden towpath bridge in the same spot.

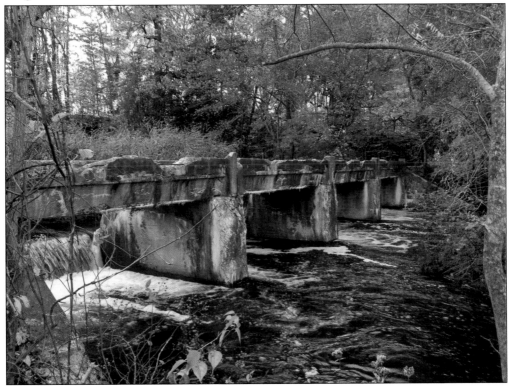

The concrete bridge leads to a stretch of towpath along a water-filled section of the canal in Mount Olive. The canal and towpath are nestled between sparse woods, creating a setting for a quiet walk. At the end of this half-mile towpath are the remains of the lock tender's house for Lock 2 West. The lock is buried, but partial walls of the stone house still stand.

Traveling out of Mount Olive and across present-day Interstate 80, the Morris Canal heads into Sussex County. This is the canal's empty prism, leading into Starport, once a busy port on the Morris Canal. The towpath, to the right, provides a peaceful walk along the canal.

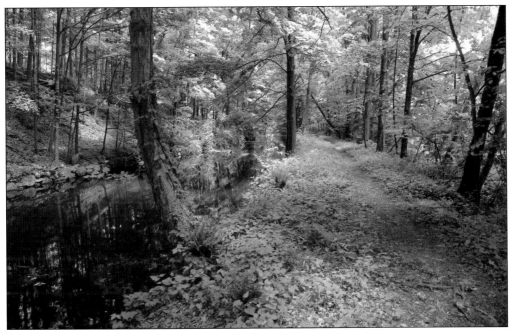

Continuing down the towpath in Starport is a water-filled section of the canal, seen here. During the last half of the 19th century, Starport was lively with the business operations of James Frenche, who used the Morris Canal to ship his goods. Stone ruins of his buildings can still be seen here.

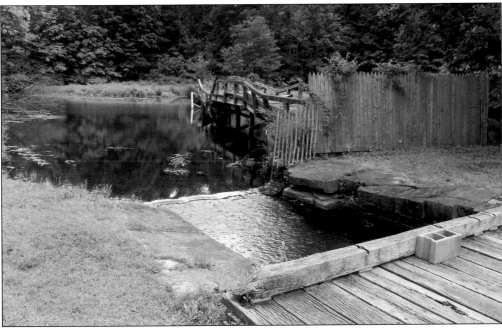

Approaching Waterloo Village, the canal meets Waterloo Lake and the Musconetcong River. The river was dammed to allow canal boats to cross between Inclined Plane 4 West and Guard Lock 3 West. In the background is the site of Plane 4 West and a replica of the mule bridge, used to pull canal boats across the river. In the foreground is the Guard Lock 3 West.

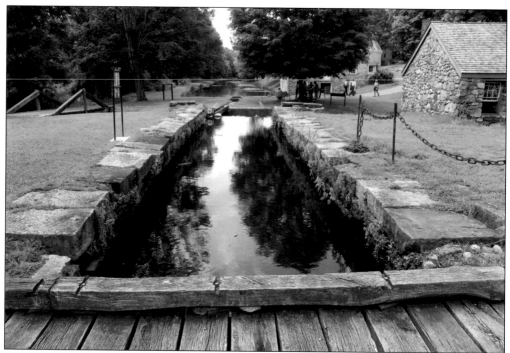

Guard Lock 3 West (above) was once a combination lock and aqueduct. This lock prevented the water level in the canal from fluctuating. Half of the lock was an aqueduct that carried the canal over the tailrace of the nearby gristmill. A narrow wooden trough is presently in the aqueduct site, extending from the other side of the lock. Below, the canal continues along in Waterloo, past Smith's General Store (right). The towpath is on the left side of the canal. Boats could pull right up to the back of the store for supplies.

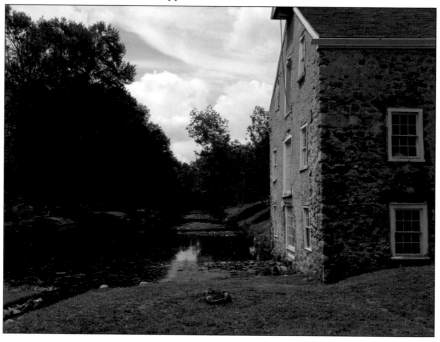

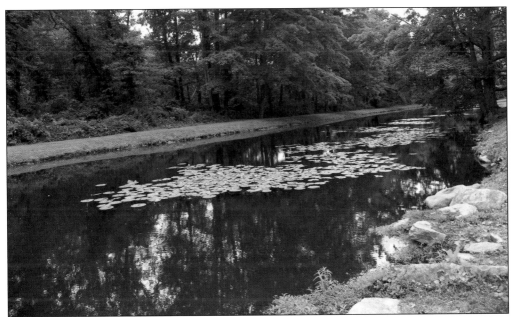

The Morris Canal leaves Waterloo Village and flows toward Lock 4 West in Guinea Hollow. Waterloo Village offered many services for the boatmen and its canal community. Smith's General Store was a place where canal boat captains and workers could buy supplies while their boats went through the lock or along the inclined plane. The town also provided overnight accommodations, a church, a gristmill, and a blacksmith shop for the mules.

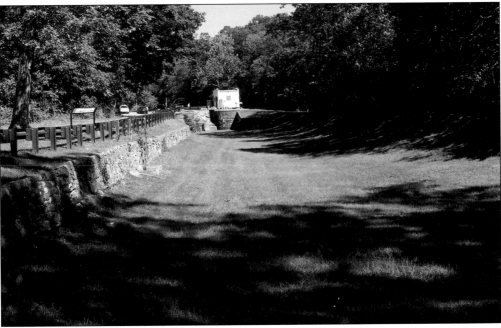

This is Lock 5 West and a section of the Morris Canal prism along the Musconetcong River and the Saxton Falls Dam. The original dam was built in the river in 1830, creating a mile-long lake where the guard lock was. From here, the canal flowed toward Hackettstown. The dam and river are to the right of the white building.

Winding along from Saxton Falls, the canal passed through Hackettstown. In this photograph, the canal's towpath is on the left; its empty prism is to the right. This peaceful stretch of the canal is located in the Florence W. Kuipers Memorial Park and is part of the Morris Canal Greenway.

Located off Route 57 in Washington is Meadow Breeze Park. This is a pretty location to find the Morris Canal, just down from "Bread Lock," where daily baked goods were available for the boatmen. The prism (at right) is overgrown, but a visitor walking along its towpath (at left) can visualize it.

Traveling up a slight rise from Route 57 in Broadway, the Morris Canal's enduring towpath can be seen between the farmer's crops in the above photograph. One can imagine the canal flowing across this beautiful landscape alongside the raised towpath, making its trek across Warren County. Farther along, the canal entered New Village. Below, the dry canal prism (right) and the towpath (left) head around to Lock 7 West. This lock was also known as "Bread Lock," because of the fresh-baked potato bread sold to the boatmen by the lock tender's wife.

This is a view of the empty canal prism, looking out from Lock 7 West in Bread Lock Park. The lock is buried, but the remains of the lock tender's house are present at the lock site. The fresh potato bread was sold at a small shack at the foot of this lock.

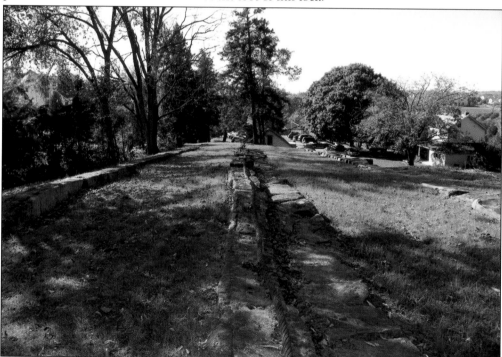

Heading toward the western terminus from Lock 7 West, the Morris Canal used Plane 8 West in Stewartsville before approaching Plane 9 West in Port Warren. Visitors can walk along Plane 9 West's remaining sleeper stones (pictured), see the remains of the powerhouse, and climb through the tailrace to the underground Scotch turbine chamber.

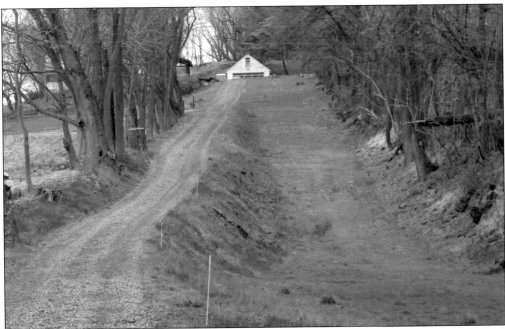

The above photograph is a view up Inclined Plane 9 West from where the small basin was located at the foot of the plane. The remains of the powerhouse are located above the trees on the left, and the inclined plane continues up behind the white building, as seen in the previous photograph. Plane 9 West, the longest plane on the Morris Canal, had an elevation change of 100 feet. The canal continues from the bottom of this plane across the highway. Below, the canal's route heads toward Phillipsburg after crossing over Stryker Road in Warren County.

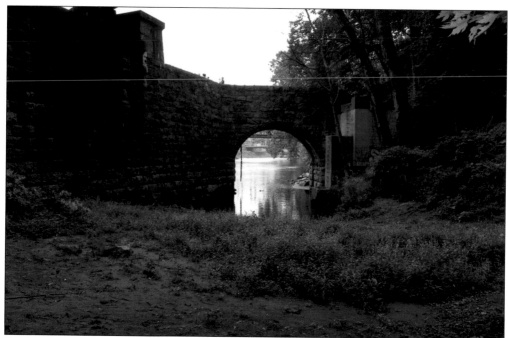

Coming from Port Warren, the Morris Canal passes through the Lopatcong and Pohatcong areas and out through its western terminus in Phillipsburg. The canal's route is now overgrown (above), but the stone archway is intact. The stone arch acted as a stop gate; large planks were lowered to close off the entrance. The below photograph of the terminus archway was taken from across the Delaware River at the Delaware Canal State Park in Easton, Pennsylvania. Inclined Plane 11 West and Lock 10 West were located in Phillipsburg. The canal used an outlet lock and a cable ferry across the Delaware River to connect with the Lehigh Navigation and Delaware Canal.

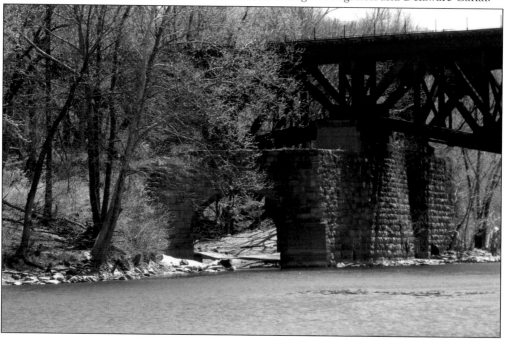

*Six*

# A Bustling Canal Returns, with Preservation

It is exciting to explore and learn about the Morris Canal's preserves, trails, and pocket parks. Much of the canal's route was either in ruins or had disappeared due to development. However, due to years of hard work from dedicated individuals and organizations, the canal is resurfacing and becoming busy again. This is a peaceful walk along one of many preserved towpaths on the beautiful Morris Canal.

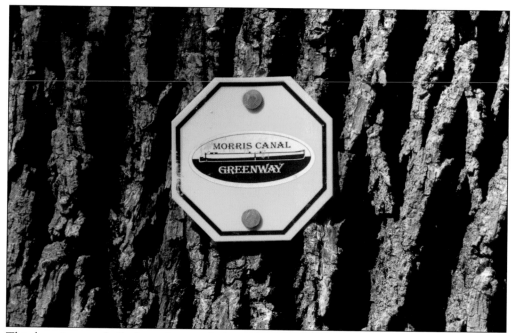

This logo is posted all along the canal. According to the Canal Society of New Jersey, "The purpose of the Morris Canal Greenway is to preserve the surviving historic remains of the Morris Canal and its associated natural environment, to interpret Canal sites to the public, and to offer recreational opportunities."

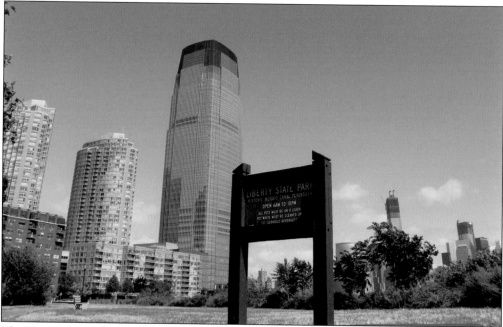

The Morris Canal Peninsula Park in Liberty State Park is located between the canal's Little Basin and Big Basin. This was where the original shipping basin was built for the Morris Canal after reaching Jersey City in 1836. In 1996, this peninsula was turned into a public space, including interpretive signs about the canal and its basins.

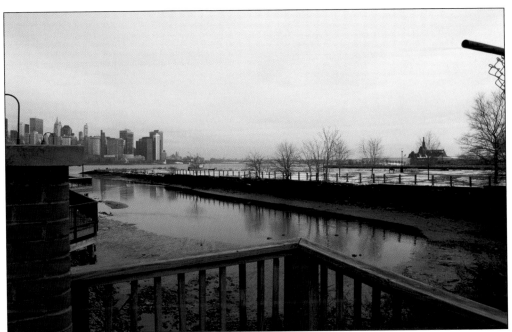

When Jersey City gave 156 acres to the State of New Jersey in 1965, an enormous cleanup followed. In 1976, the state dedicated this land, Liberty State Park, as New Jersey's bicentennial gift to the nation. The Morris Canal section of Liberty State Park extends into the Hudson River from Paulus Hook (pictured). (Courtesy of Derek S. Reilly.)

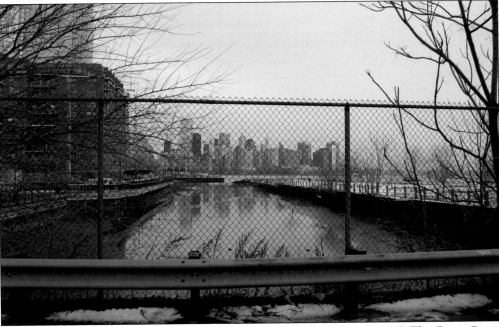

This is the modern-day view of the once shack-filled Little Basin (see page 32). The Green Street Boat Club "members" felt that the state did not have the right to tell them to leave, because their makeshift shacks and docks were part of the historic Morris Canal Basin. (Courtesy of Derek S. Reilly.)

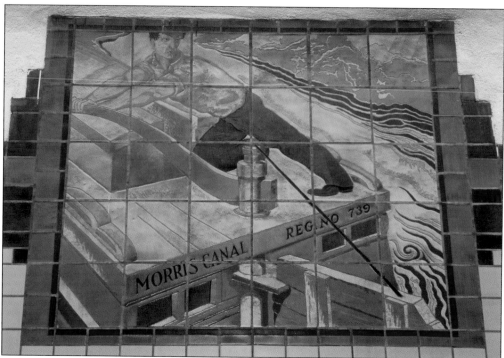

These photographs show two of the eight Morris Canal tile murals produced for the Newark subway system by artist Domenico Mortellito depicting life along the Morris Canal (a third is pictured on the back cover). The Morris Canal flowed through Newark near the Passaic River, the original terminus. The Newark subway was constructed in 1929 in a section of the Morris Canal bed. The Mortellito Memorial 2003 plaque states: "The murals were installed in 1935 and were the first use of public art for an underground transit line in the United States." The artist created these tiles under the Works Progress Administration, a government agency started during the Great Depression to create employment. Many public works of art were created through the program. Both photographs were taken inside Newark subway stations in 2013.

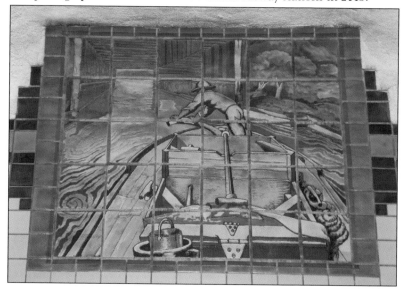

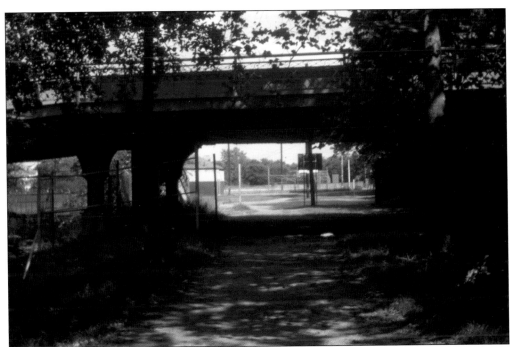

Shown above in 1979 is the Berkeley Avenue Bridge and the path of the Morris Canal at Wright's Field in Bloomfield. The Berkeley Avenue Bridge is one of the 259 bridges built to cross the canal. It will be demolished, but the state will maintain some of its characteristics in the new bridge design and will include interpretive signs. There are several sections, including Wright's Field and property around the Collins House, that are designated Morris Canal Greenway. The Collins House (below) is seen in 2011. The house has been unoccupied since 2005. The Friends of the Collins House advocate for its preservation and have a long-term goal of seeing it restored. It is on Preservation New Jersey's 10 Most Endangered Historic Places list for 2013. (Above, courtesy of Frederick Branch; below, courtesy of Richard Rockwell.)

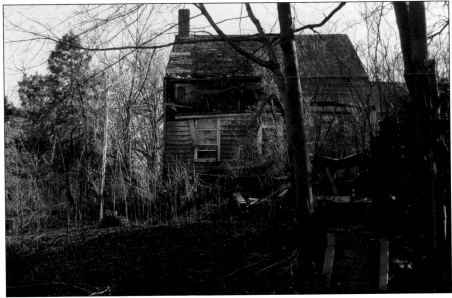

The Little Falls Morris Canal Preserve, created in 1994, runs above the Passaic River and behind Main Street in Little Falls. Some of its paved trails follow the route of the Morris Canal, and it overlooks the site where the brownstone aqueduct once carried the canal over the river. The Morris Canal Greenway offers a hiking trail along the canal path, from Little Falls to nearby Woodland Park.

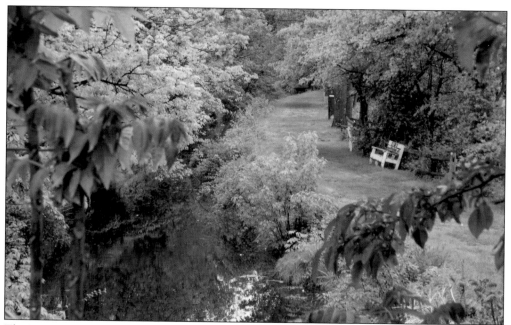

The Morris Canal Park and Jack W. Kuepfer Sr. Nature Preserve in Clifton was re-dug by hand when restorations of the canal started in 1986. This photograph peers through the dense park trees onto the water-filled prism (left) and towpath (right). The park also offers a picnic area and attractive gardens. Jack Kuepfer was given the Take Pride in America Award for establishing this park.

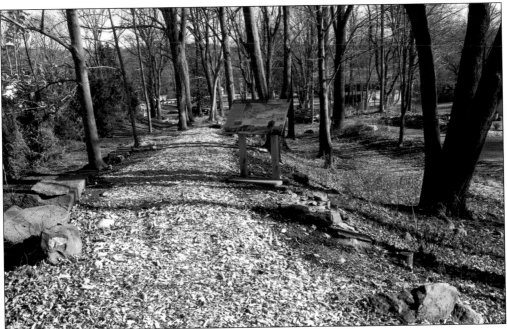

In Montville, Montville Village, a narrow pocket park along Inclined Plane 9 East's location was completed and dedicated in July 2013. Inclined Planes 8, 9, and 10 East came through Montville Township. This pocket park includes remains of sleeper stones and an information kiosk with diagrams of "Montville Village 1890," as well as the inclined planes.

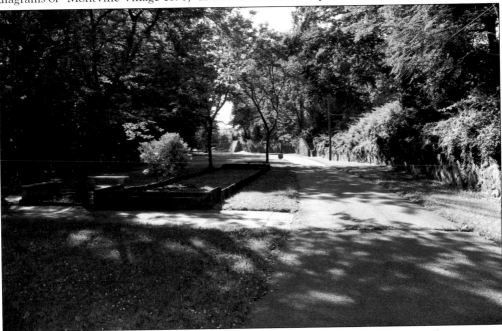

This is Canal Side Park, located at the end of upper Plane Street in Boonton. It sits on top of a filled-in section of canal that ran between Main Street, above the stone wall beyond the photograph to the right, and the Rockaway River beyond the photograph to the left. The park offers bocce ball, horseshoes, a basketball court, and trails.

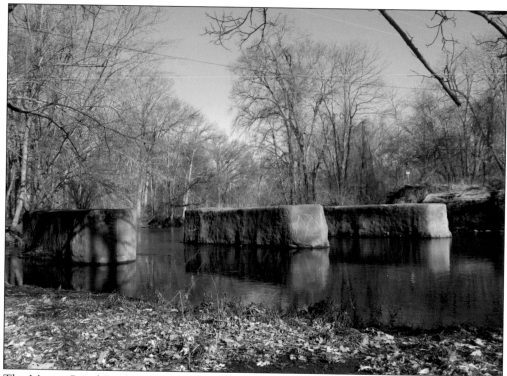

The Morris Canal Rockaway River Aqueduct in Denville Township is on the list of 10 most-threatened resources in New Jersey. Future demolition is under discussion, due to its possible involvement in local flooding. The aqueduct's concrete bases, left standing when the canal was dismantled, are protected in the New Jersey and National Registers of Historic Places. Proof of no other solution is needed before removal.

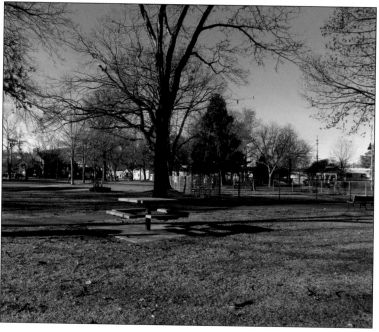

Founded in 1722, Dover was revitalized when the Morris Canal came through. Locks 6 and 7 East, and the largest basin on the canal, were located in Dover. Pictured here is JFK Commons, a park located on the site of the largest basin. The East Clinton Street sidewalk alongside the park (visible at upper left), between Bergen and Essex Streets, follows the canal's old towpath.

The right photograph, taken in 2009, shows the restored tailrace arch of Plane 2 East's turbine chamber in the Ledgewood Canal Park. The archway was collapsing prior to its restoration. Plane 2 East is one of the four inclined planes of the Morris Canal that are still well preserved. This turbine pit had been exposed to weather, contributing to the archway's decay. Grates over the ground-level opening of the powerhouse remains and a steel pavilion were installed to allow visitors to look into the pit and to limit the amount of rain entering. The below photograph, taken in 2013, is of the same powerhouse under the pavilion. The stairs lead to the grated opening of the turbine pit. (Right, courtesy of the Canal Society of New Jersey.)

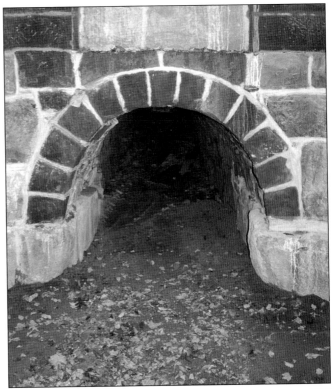

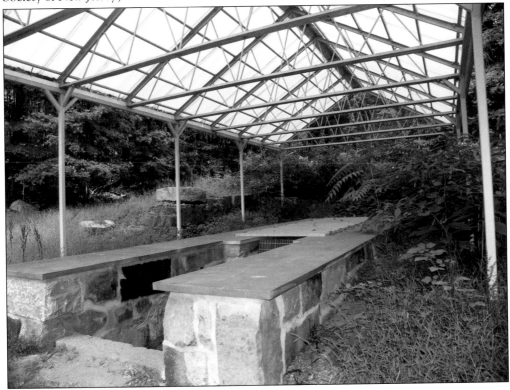

The Drakesville Historic District in Ledgewood includes the King Store and King House Museums, and the Silas Riggs House. The plan to recommend the district to the National Register of Historic Places began in 2009, and on April 18, 2013, the Drakesville Historic District was listed. The register protects historical and archeological resources.

The Roxbury Township Historical Society owns and operates the Silas Riggs "Saltbox" House (pictured). It is located in Ledgewood, next to the King Store and across the street from the site of the lower canal basin. "A Saltbox Christmas" is held each December, and other events take place at the Saltbox House.

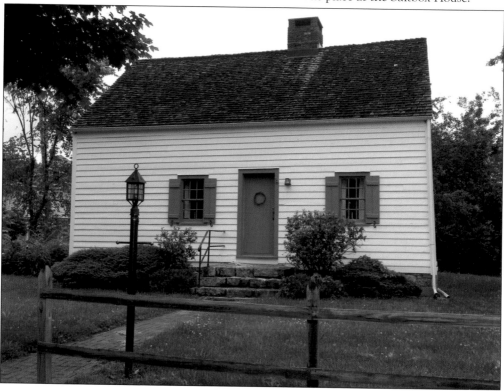

In September 2012, installation of a five-ton-capacity wagon scale (to the left of the porch) was completed at the King Store in Historic Drakesville. The original scale, used to weigh coal and other products during Morris Canal times, was removed sometime in the mid-1900s. Pictured here is Miriam Morris, 2012 president of the Roxbury Historic Trust Inc. (Courtesy of the Roxbury Historic Trust Inc.)

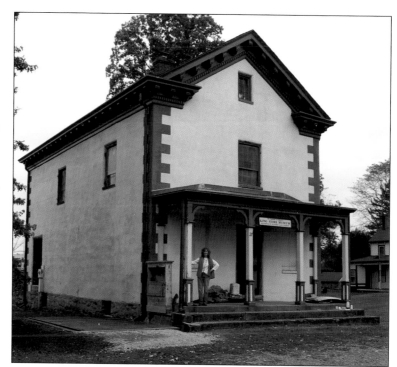

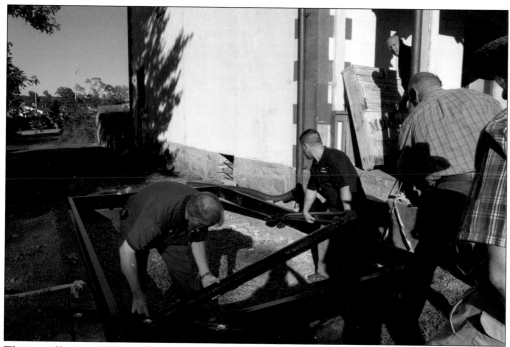

The installation of the replacement scale began on September 11, 2012. When completed two days later, the scale was completely operational and accurate to within a few pounds. Pictured here are, from left to right, Dave and Nick Farnham of Farnham's Scale Systems, Charles Alpaugh, and Nigel Barnes. (Courtesy of the Roxbury Historic Trust Inc.)

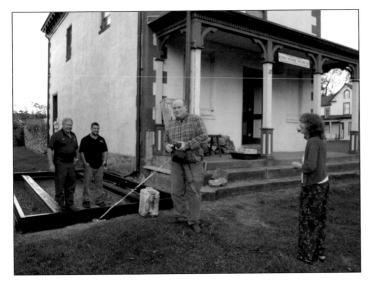

The 1910 Moline Pitless replacement scale was located in Indiana, saved from demolition, taken to Vermont, and restored to working condition by Farnham's Scale Systems. Volunteers prepared the concrete enclosure and made the oak plank decking. Shown here are, from left to right, Dave Farnham, Nick Farnham, antique scale enthusiast Brook Paige, and Miriam Morris. (Courtesy of the Roxbury Historic Trust Inc.)

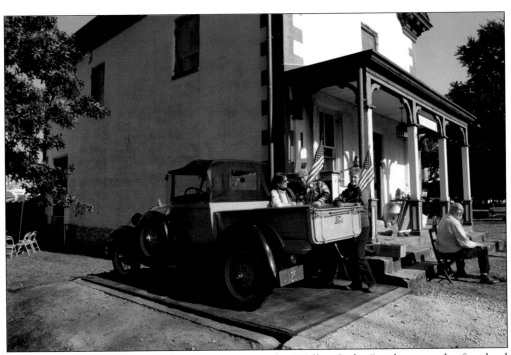

After the October 14, 2012, dedication ceremony, this "Yellow Jacket" pickup was the first load on the restored scale. The King Store keeps its turn-of-the-century look as restorations continue through different types of funding. The King Store and King House Museums are located at 209–211 Main Street, Ledgewood. Pictured here are, from left to right, Lynda de Victoria, Don Erickson, Bierce Riley, and Charles Alpaugh (seated). (Courtesy of Stanley L. Stronski.)

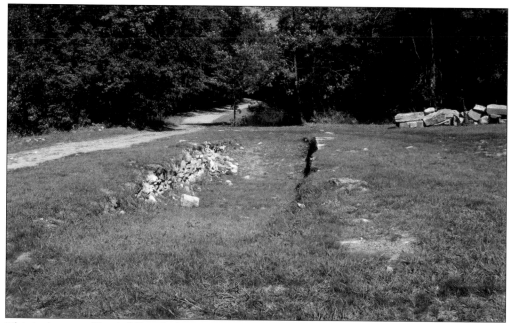

This is the site of Lock 2 East before its restoration, when it was partially dismantled and buried. John C. Manna, Wharton Borough grant coordinator, said, "When I was appointed to the Borough's Main Street revitalization committee in 2005, I proposed the idea to create an outdoor museum by restoring the lock, building on the unique strengths of Wharton, and to make the borough a destination."

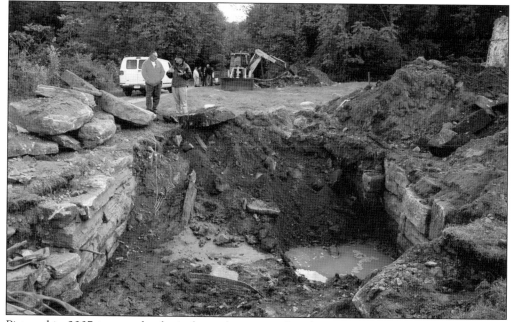

Pictured in 2007 is an archeological test that was undertaken to assess the buried Lock 2 East's structural condition. Testing disclosed that the lock's walls were intact. The project will build the walls up to their historic elevation and will include reconstructed wood lock gates. (Courtesy of Canal Society of New Jersey.)

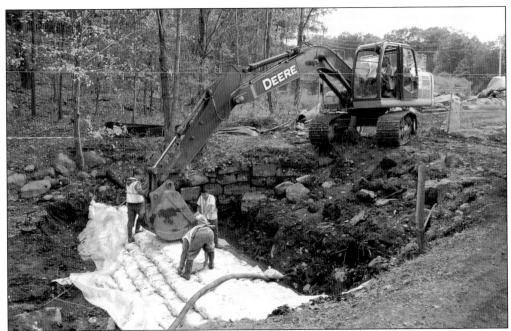

In this 2012 photograph, sandbags are distributed by a backhoe inside the excavated Lock 2 East to create a dam to prevent water from coming in. Due to funding guidelines and Lock 2 East's listing in the New Jersey Register of Historic Places, special care was required during digging. (Courtesy of the Canal Society of New Jersey.)

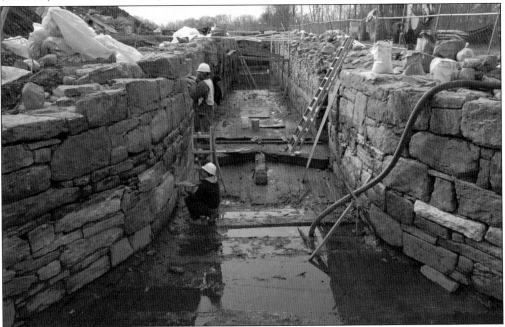

The reconstruction of Lock 2 East, Wharton, is under way in 2012. The workers found many of the lock's original working parts in the earth, removed from the lock chamber. At the restoration's conclusion, the lock will be built up to its original height by the addition of five feet of new stonework. (Courtesy of the Canal Society of New Jersey.)

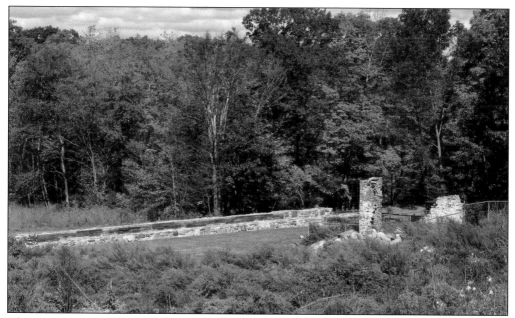

This is the restored Lock 2 East and the remains of the lock tender's house seen from the embankment near the deserted tracks of the Central Railroad of New Jersey. The goal of the preservation is to restore the lock and all of its features, and, eventually to allow visitors to go through the lock from the canal prism to the basin and back again.

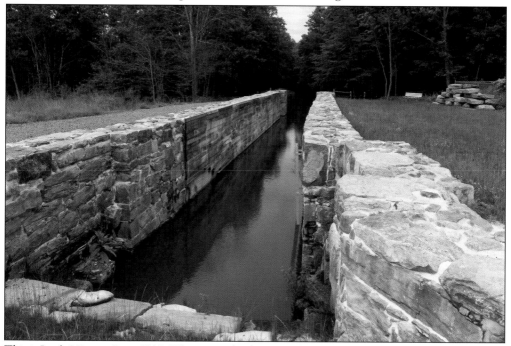

This is Lock 2 East in June 2013. When completely restored, Lock 2 East will be the only operational lock in New Jersey. It is a quiet, level walk along the canal to this historic lock site. The towpath and surrounding park are popular locations for walking, hiking, fishing, and the annual fundraiser for canal-related restorations, Canal Day Music and Craft Festival.

This lock tender's house is now home to the Lake Hopatcong Historical Museum, located on the grounds of Hopatcong State Park in Landing, at the outlet of Lake Hopatcong. The park also has the Scotch turbine from Plane 3 East, housed near the dam. In addition, there are open areas to walk near the dam and along the Musconetcong River as it flows from Lake Hopatcong.

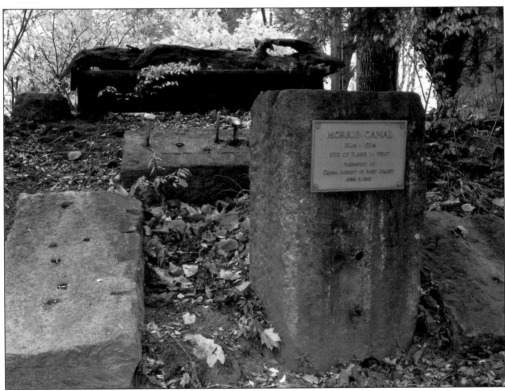

This plaque reads, "Morris Canal, 1824–1924, Site of Plane 1 West, Presented by Canal Society of New Jersey, June 5, 1983." Later, after a two-year legal process spearheaded by the Canal Society of New Jersey, a two-acre section of the canal at Plane 1 West was acquired in August 2010, with the goal of creating a historic site and pocket park. Pictured here are sleeper stones and spikes from Plane 1 West.

In the 1970s, Waterloo Village was a busy, restored canal town; later, an early American farm and a re-creation of a Native American settlement were added. Waterloo closed in 2006 for financial reasons. The New Jersey Department of Environmental Protection, Division of Parks and Forestry took over in January 2007, reopening the site in 2010. The Canal Society of New Jersey reopened the gristmill in 2011 after money was raised to fix its roof, a popular site during Annual Canal Heritage Days. The Canal Society of New Jersey, Friends of Waterloo Village, Winakung at Waterloo, Waterloo Methodist Church, and the New Jersey Department of Environmental Protection, Division of Parks and Forestry, State Park Service work together with restorations and education of Waterloo's history. Waterloo is accessible to the public during state park hours for guided tours and special events.

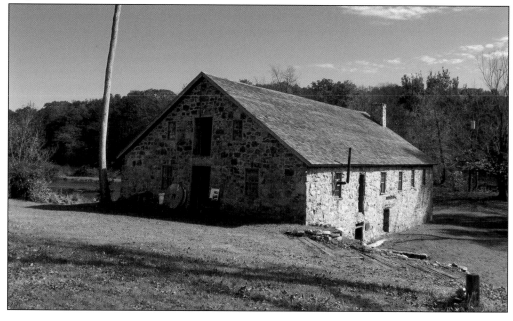

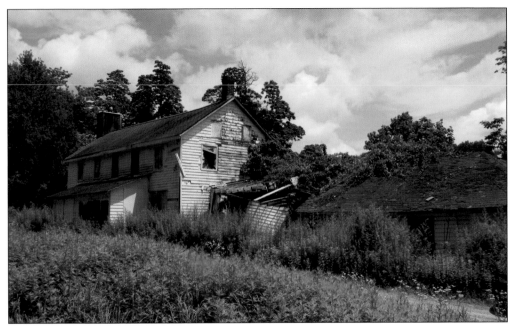

The state park and the Canal Society of New Jersey would like to see Lock 4 West's lock house in Guinea Hollow, pictured here in 2013, restored for historical and environmental uses. Other planned improvements include the restorations of the lock at nearby Saxton Falls and its section of canal filled with water, the canal towpath used as a trail along Saxton Lake, and canal boat rides on the lake.

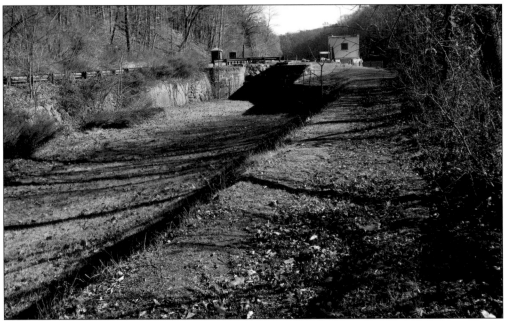

This section of canal bed at Lock 5 West, Saxton Falls, was filled with water for many years and used as a public swimming area. In the 1970s, this historic Morris Canal site almost vanished. A proposed reservoir was to be built to supply drinking water to nearby Hackettstown. Fortunately, the measure did not pass, and this historic site remains available for the public to explore.

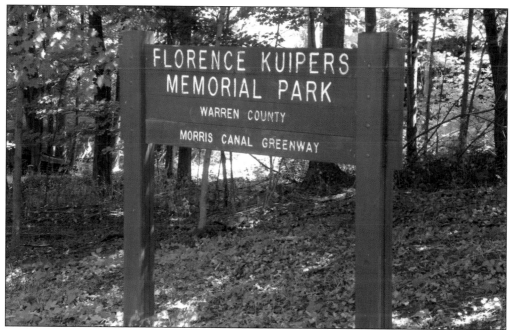

Florence W. Kuipers Memorial Park is located in Hackettstown. Kuipers rode her horses along the Morris Canal towpath and became an early member of the Warren County Morris Canal Committee and Board of Recreation Commissioners, promoting the idea of a greenway along the canal's towpath across Warren County. Shown below are the ruins of the canal store at Florence W. Kuipers Memorial Park. The canal store, adjacent to the canal's towpath, was built by Silas Harvey in about 1831. The canal store received goods shipped on the canal and sold them to boatmen and local residents. Harvey also was a freight agent for the Morris Canal and Banking Company and built a freight depot along the canal and Main Street.

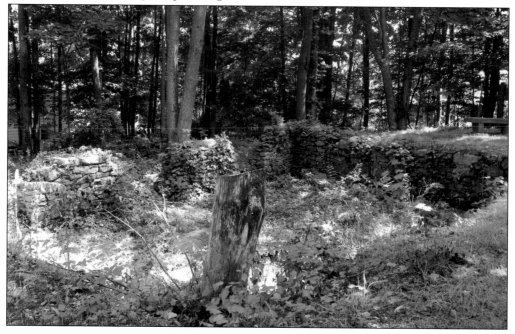

The above photograph shows the entrance to the Morris Canal Trail in Port Murray. As visitors climb down the stairs, visible at right, they come to a low footbridge that crosses the canal's rain-filled prism to the towpath (below). Walking down the towpath with the canal prism to the right, one will come to a Morris Canal Greenway information kiosk and the Port Murray boat basin. The boat basin and towpath area are all part of the Dennis Bertland Heritage Area. Port Murray was first a busy port on the Morris Canal at Plane 5 West, later becoming a railroad stop. Port Murray was named after the third president of the Morris Canal and Banking Company, James B. Murray.

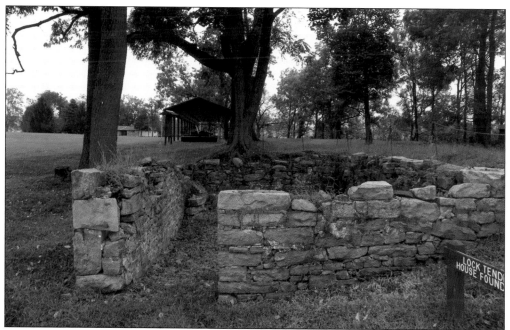

Bread Lock Park, near New Village, has Lock 7 West, a prism, lock tender's house, and mule barn sites. The above photograph shows the lock tender's house foundation. The buried lock and canal prism are to its right. The below photograph shows the prism with the lock and lock tender's house to the left, and the towpath and former mule barn site to the right. The mules stayed in the mule barn at night when the lock was closed. At center left is a built-to-scale model canal boat under a protective roof. It includes a hatch with a ladder that takes a visitor down into tight living quarters. The Warren County Historical Learning Center is located at Bread Lock Park. It has a small museum that includes a working model of an inclined plane and lock.

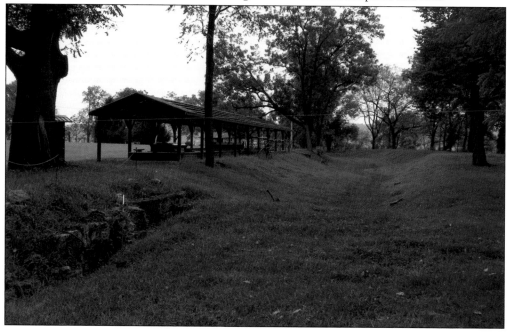

James Lee Jr. guides a tour of Inclined Plane 9 West in Port Warren. He grew up at Plane 9 West, and his maternal grandmother was the daughter of a canal boat captain. Included in the tour are the remains of the powerhouse, the tailrace tunnel, the turbine chamber, the inclined plane, and the Jim and Mary Lee Museum, located in the plane tender's house.

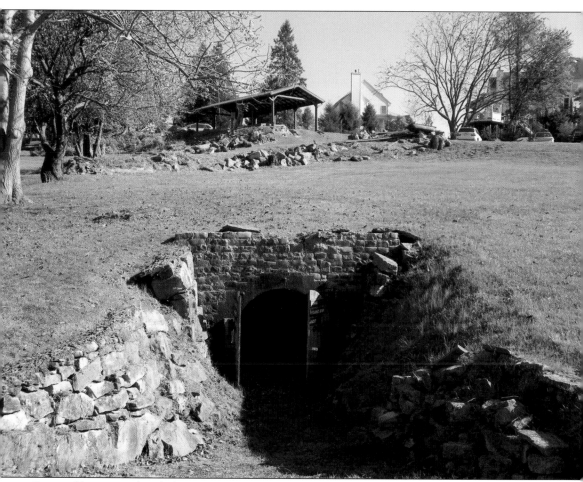

Pictured here at Inclined Plane 9 West are the sheltered remains of the powerhouse (top) and the opening to the tailrace tunnel (bottom). Water from the upper section of the canal was directed down into the powerhouse's underground chamber, providing power to the Scotch turbine. The used water was removed through the tailrace tunnel and sent back out into the canal.

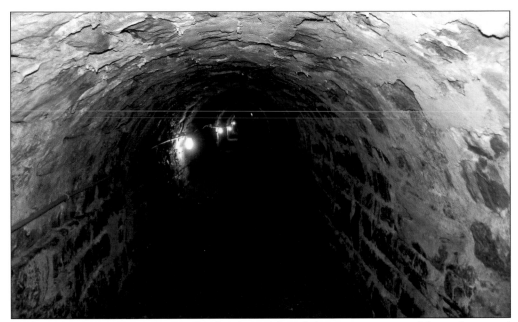

In the early 1970s, James S. Lee Sr., his family, and friends began excavation of the underground turbine chamber and tailrace tunnel. The turbine was damaged, but its buried stone chamber and tailrace were both in one piece. As a visitor walks down the long tailrace tunnel (above) into the turbine chamber, they come to the Scotch turbine in the stone chamber about 30 feet underground, beneath the powerhouse (pictured below with James Lee Jr.). Today, Inclined Plane 9 West is owned by Warren County and is being developed as part of the Morris Canal Greenway. Plane 9 West is a National Civil Engineering Landmark.

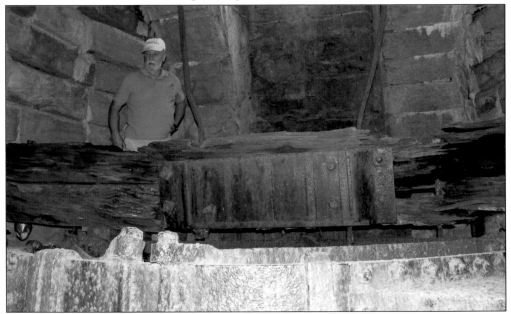

Once completed, the Morris Canal Greenway will proudly follow the Morris Canal's course from the Hudson River, through six counties, and out to the Delaware River—a modern-day tribute to this "engineering marvel."

# BIBLIOGRAPHY

Canal Society of New Jersey. *On the Level* (newsletter). January, May and September 2007, September 2010.

Groller, Robert R. *The Morris Canal Across New Jersey By Water and Rail*. Charleston, SC: Arcadia Publishing, 1999.

HJGA Consulting, Architecture and Historic Preservation. *Historic Site Master Plan and Feasibility Study, Lock 2 East of the Morris Canal*. February 4, 2008.

Macasek, Joseph J. *Guide to the Morris Canal in Morris County*. West Orange, NJ: Morris County Heritage Commission, Midland Press Inc., 1996.

# DISCOVER THOUSANDS OF LOCAL HISTORY BOOKS FEATURING MILLIONS OF VINTAGE IMAGES

Arcadia Publishing, the leading local history publisher in the United States, is committed to making history accessible and meaningful through publishing books that celebrate and preserve the heritage of America's people and places.

Find more books like this at
## www.arcadiapublishing.com

Search for your hometown history, your old stomping grounds, and even your favorite sports team.

Consistent with our mission to preserve history on a local level, this book was printed in South Carolina on American-made paper and manufactured entirely in the United States. Products carrying the accredited Forest Stewardship Council (FSC) label are printed on 100 percent FSC-certified paper.

MADE IN THE USA